STYLISH WEDDINGS

Create Dramatic Wedding Photography in Any Setting

Kevin Jairaj

AMHERST MEDIA, INC. ■ BUFFALO, NY

ABOUT THE AUTHOR

Photo © Alycia Savage Alvarez.

Kevin Jairaj is an internationally award-winning fashion and portrait photographer and educator based in Dallas, Texas.

He has been commissioned to photograph weddings and events in London, Hawaii, Trinidad and Tobago, the Bahamas, Mexico, Jamaica, Anguilla, and Aruba in addition to the work he does in Texas and throughout the United States. Kevin is also a favorite among the celebrity crowd and has shot weddings and events for many musicians, actors, and famous athletes.

Kevin is one of only a few people in the world to hold the Triple Master title from WPPI as well as a Master of Photography from PPA. His work has been published in *Photo District News, American Photo, Rangefinder, USA Today, Professional Photographer, Destination Weddings,* and *People,* just to name a few.

DEDICATION

I would like to dedicate this book to my parents, Keith and Mala, for their undying love and support and to Alycia for pushing me not only to be a better photographer, but an even better person.

Published by:
Amherst Media, Inc.
P.O. Box 586
Buffalo, N.Y. 14226
Fax: 716-874-4508
www.AmherstMedia.com

Publisher: Craig Alesse
Senior Editor/Production Manager: Michelle Perkins
Editors: Barbara A. Lynch-Johnt, Harvey Goldstein, Beth Alesse
Associate Publisher: Kate Neaverth
Editorial Assistance from: Carey A. Miller, Sally Jarzab, John S. Loder
Business Manager: Adam Richards
Warehouse and Fulfillment Manager: Roger Singo

ISBN-13: 978-1-60895-933-4
Library of Congress Control Number: 2015939885
Printed in the United States of America
10 9 8 7 6 5 4 3 2 1

www.facebook.com/AmherstMediaInc
www.youtube.com/c/AmherstMedia
www.twitter.com/AmherstMedia

Contents

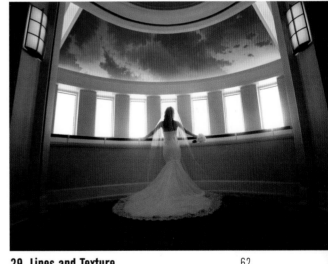

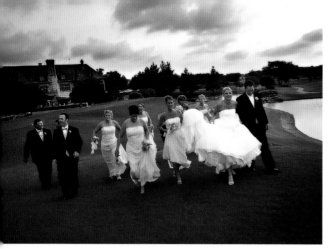

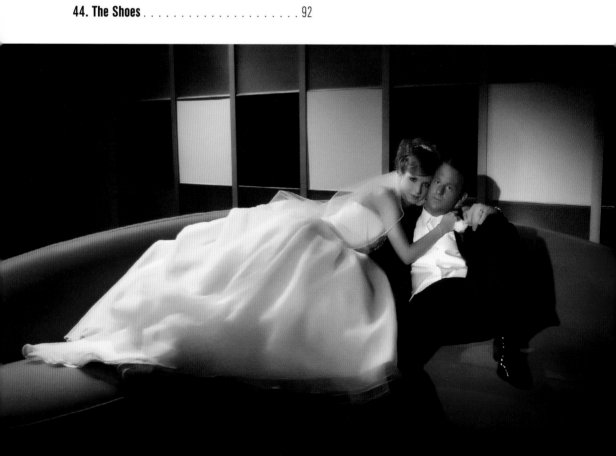

Introduction

WHAT COUPLES WANT

As a wedding photographer, it is my goal to create contemporary, fashion-forward images of every aspect of the wedding day for my clients. I strive to produce images that are modern, dramatic, stylish, and unexpected. I want my images to make my clients feel like celebrities. When they view their albums, I hope they'll say, "Wow! Is that really me? Did that really happen?" I want their friends and family to say, "You look like a model! You should be in a magazine."

I take my time photographing my subjects, with the goal of producing images that speak to them and communicate who they are. Wedding photographs are mementos, things to be cherished for years, decades, and even generations to come. Each client deserves the very best and most personal images I can produce. I look at each wedding and each bridal session as a unique opportunity to produce fresh, unforgettable work.

Achieving that goal means staying on top of trends, in terms of both fashion and technology. I am always looking at fashion magazines from all over the world. It helps me to keep pushing forward creatively and allows me to enhance my clients' experience. Staying up to date on photographic trends and new technologies allows me to keep evolving as an artist as well.

PERSONAL STYLE

The biggest compliment, for me, is hearing someone say, "I knew that was your image right away (because of the lighting, posing, etc.)." Cultivating a personal style takes time and effort, but it's important. The rewards of creating images that are consistent with your personal style come when you present your clients' albums and images and see the joy on their faces.

ABOUT THIS BOOK

In this book, you will learn how I approach shooting throughout the wedding day. I will show you the posing, lighting, and compositional approaches I have used to create stylish and elegant images of the bride, stand-out photographs of the groom, and innovative shots of the wedding party. You will also learn how I capture the other important details of the day—from the location, to the flowers, cake, rings, and more. With these tips, you'll be able to re-create similar looks for your own clients.

66 It is my goal to create contemporary, fashion-forward images of every aspect of the wedding day 99

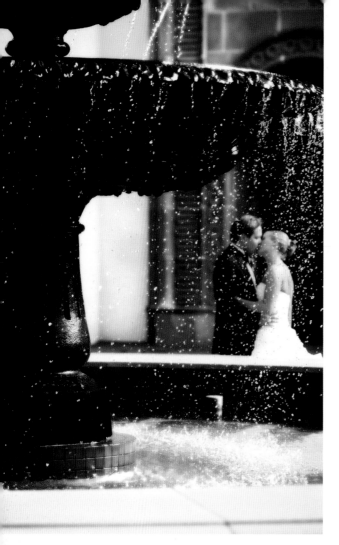

NATURAL MOMENTS

I like to capture couples being themselves. I am not big on posing, so I tend to simply prompt couples. I might say something like "nuzzle in." At that point, I work from a distance with a long lens and capture natural moments as they unfold.

KEY IDEAS

Each of these images documents a natural, romantic moment during the wedding day, and each has a unique feel. In the top-left image, the water droplets add a layer of interest and heighten the romance. For the image below, I shot from a low angle to show the grandeur of the ceremony location. The top image on the facing page depicts the contented joy the couple was sharing. In the final image (facing page, bottom), the couple is lost in a private, tender moment that naturally unfolded.

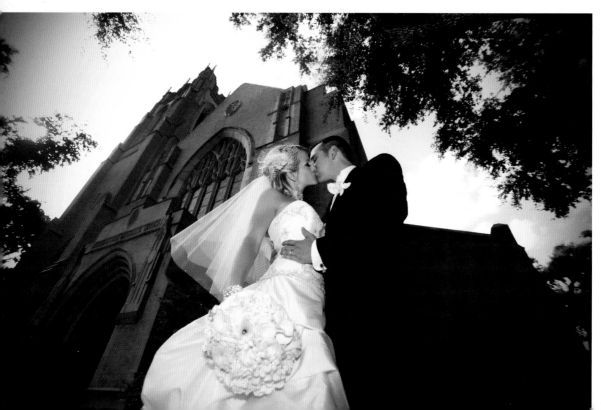

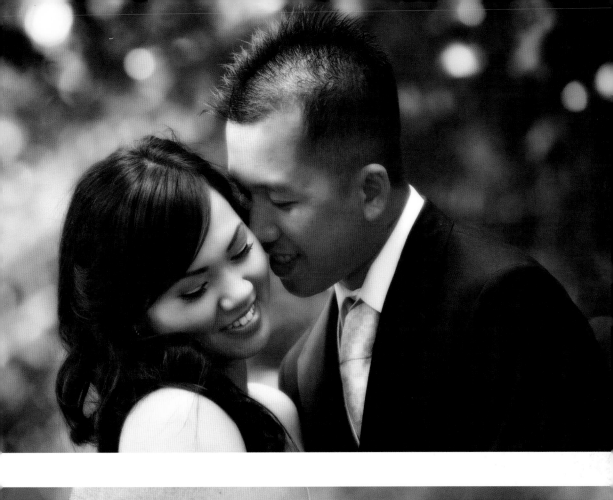
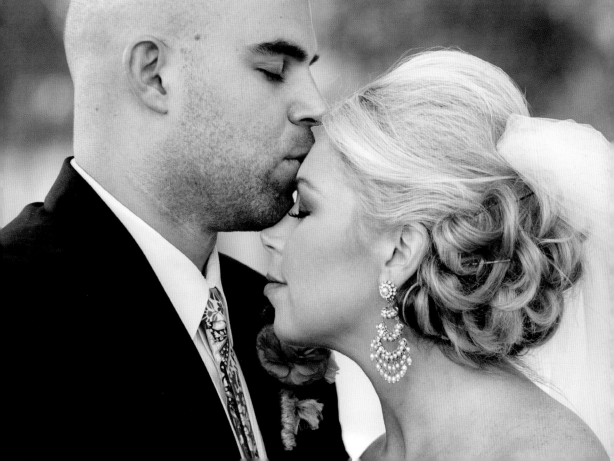

2 | Almost Angelic

THE BACKSTORY

The bride was walking down the hallway to meet her father, who was going to walk her down the aisle. I was walking behind the bride and the compositional qualities of the space compelled me to capture the image.

THE COMPOSITION

I like to use a wide angle lens for many of my wedding images. Here, I got down low behind the bride to get the perspective I was after. Note that the chair rail molding and the baseboards form converging lines that draw the viewer's gaze directly to the bride. Note, too, that the contrast in the image draws attention to the subject. Compositional guidelines tell us that the eye is drawn to the brightest part of the image.

Here, the brightest tones are in the gown and the glowing arched doorways that frame the bride.

I shot several images. This one was my favorite due to the perspective; I liked the way the doorways lined up in the shot. The terrific halo effect also won me over. The bride looks almost angelic.

66 This image has won more awards than any other I have shot to date. It's a photograph that many brides have brought up during their consultations. 99

Specs
Canon EOS 5D • 16–35mm f/2.8 lens at 16mm
f/2.8, 1/20 second, ISO 800

AWARENESS LEADS TO ACCLAIM

This image has won more awards than any other I have shot to date. It's a photograph that many brides have brought up during their consultations.

The lesson here is to always be aware of your surroundings. When moments of beauty present themselves, with luck and skill, you might find that you can capture an image that will speak to viewers for years to come.

LIGHTING AND SHOOTING

This image was made with available light and was not set up in any way. I shot at f/2.8 and 1/20 second. I used a slow shutter speed to capture a hint of movement.

POSTPRODUCTION

I tweaked the saturation and contrast in Photoshop to intensify the reds in the wall in the final image. Beyond that, the image required no editing.

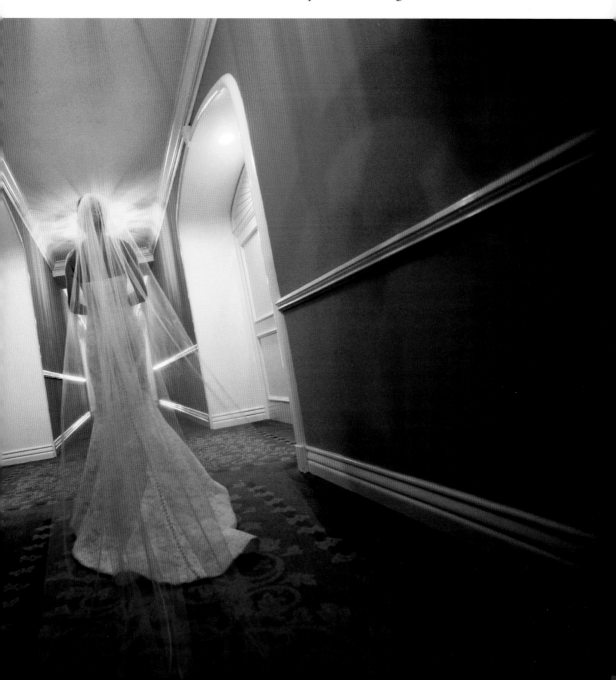

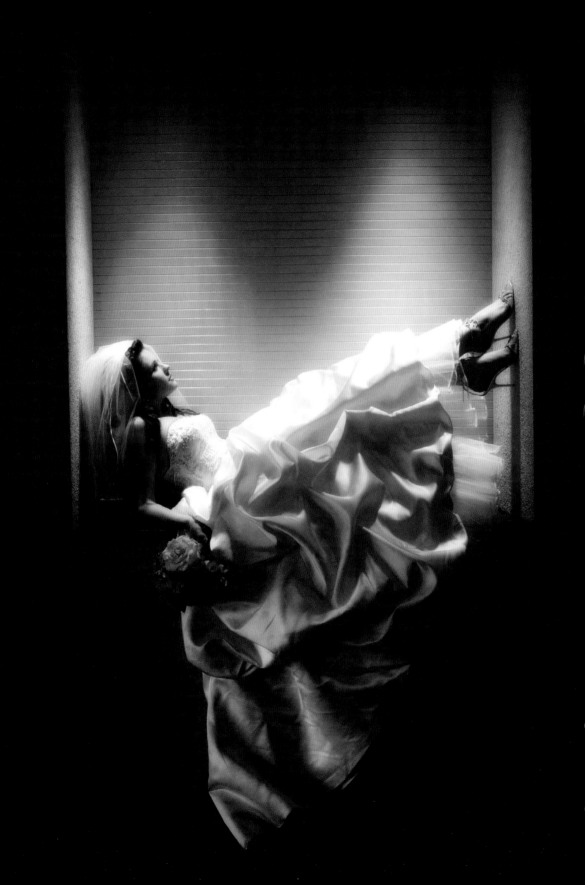

THE CHALLENGE

Overhead lighting often looks dramatic and intriguing on architecture, but it's rarely flattering on people. The harsh shadows emphasize small imperfections and can leave the subject's eyes completely obscured by deep shadow.

POSING

The key to working with these lights, so common in the commercial venues where weddings are often shot, is to tip the subject's face up toward the light. This reduces the sharp angle between the light and the planes of the face for a much more flattering look. As you can see in the images to the right and on the facing page, the look of the harsh lighting is still *quite* dramatic—but now it's also very attractive!

SHE LOVED HER SHOES

The bride shown on the facing page was very fond of her shoes and wanted to show them off in her portraits. We walked through the lobby looking for a place to create a portrait, and I found this little room—an offset nook where guests could use the telephone.

All of the lighting for this image came from two canned lights overhead. I had her tilt her face up toward the ceiling so that one light illuminated her face and the other lit her dress. I was able to ensure that the dress held detail and created a beautiful light and shadow pattern in the folds of the gown's full skirt.

I like the dramatic shadow pattern on the wall as well. It adds impact and reinforces the bride's prominence in the photograph. The shadows also naturally create a vignette in the image.

This portrait was one of the bride's favorite shots from the day.

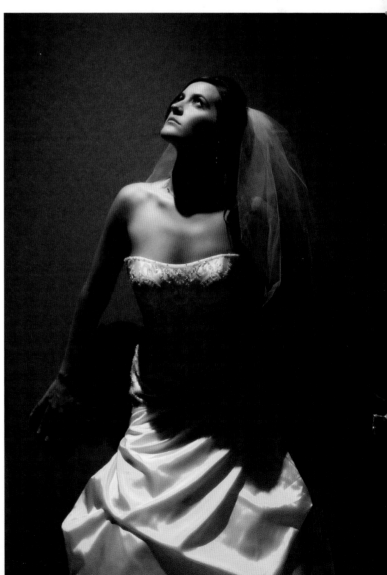

Architectural Impact

INSPIRATION

I love using architecture in my clients' wedding images. If there is anything about the ceremony site or reception venue that really stands out, I make it my goal to find a way to work it into some of the photographs. When you look around, remember that the aspects of the location that speak to you likely impressed the bride and groom as well. In fact, it may well be that the sense of history, majesty, or other evocative quality of the place persuaded them to select it as the stage for their event.

SUBJECT SIZE

Throughout most of the wedding day, the subjects occupy the majority of the image frame. When it is my goal to showcase the venue, however, I keep the subjects small in the frame, typically shoot from a low angle, and use a wide-angle lens so that I can include as much of the building and its surroundings in the photograph as possible. I avoid using fisheye (extreme wide angle) lenses, though, as they can distort the architectural lines.

TWO IMAGES, TWO GOALS

The bride in the image on the left loved the back of her dress. I opted to pose her on this dramatic stairway at Symphony Hall in Fort Worth, TX, to show the splendor of the dress. The color, the way she is framed by the doorway, and the leading lines in the scene all contribute to the success of this dramatic, stylish photograph.

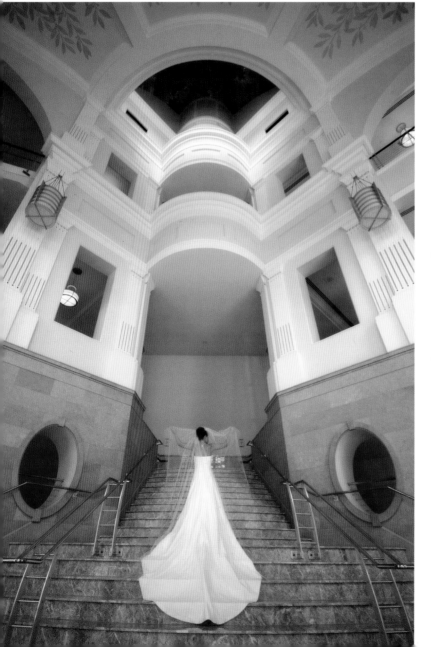

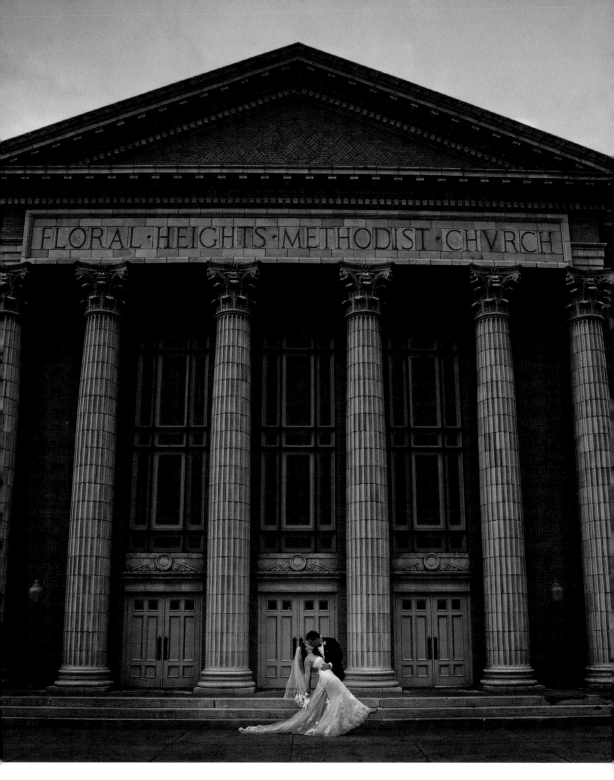

For the above image, I had the couple stand in this spot, between two columns, and prompted the groom to dip the bride.

Again, I used a wide angle lens and shot from a low angle to capture a dramatic photograph.

MAKE HER DAY

Brides pay a lot of money for their bouquets, shoes, and makeup application. Getting great images that showcase these elements is important. After all, close-up shots of these details help to tell the story of the day and speak to the bride's personality.

This trio of images has a light, airy feel and a modern, romantic vibe. In them, I focused on the bride's elegant, fresh eye makeup, the pop of color of her beautiful blue suede shoes, and then did a full-length shot to create a contemporary, magazine-style shot that shows off her beautiful gown and vintage-inspired headpiece.

A CLOSE CROP

Tight cropping can eliminate distractions and enhance the message that your image sends to viewers.

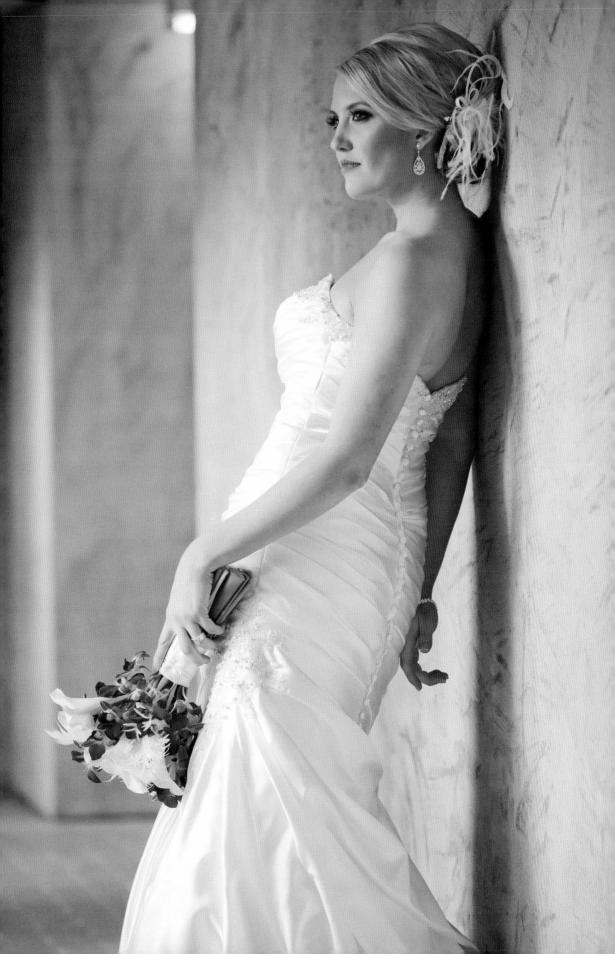

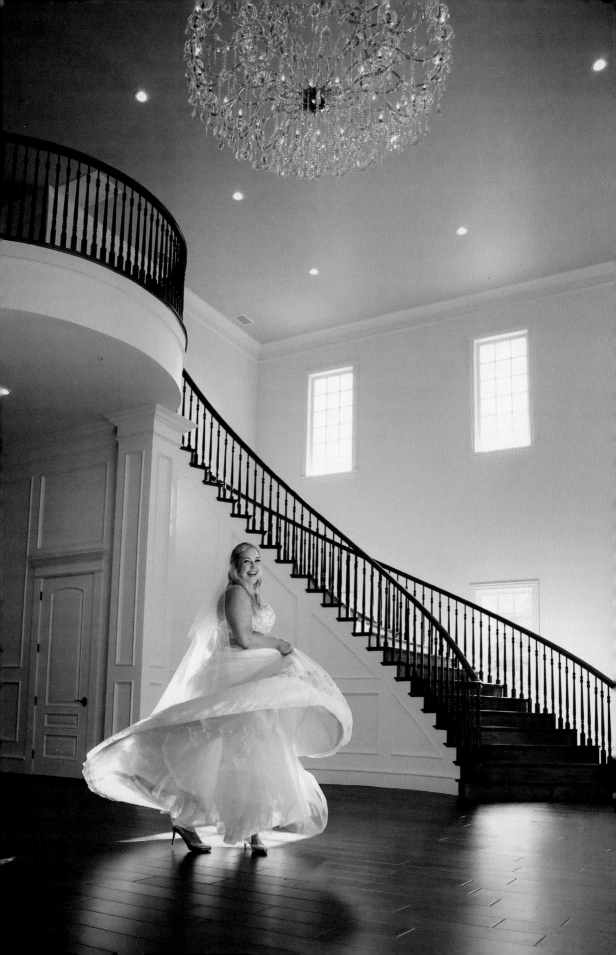

CAPTURING MOTION

To create the main image (facing page), I asked the bride to twirl around. As she turned, a big smile spread across her face. I captured a series of shots of the action, but this image was my favorite. I love the joy on her face, her position in the frame, and the light, open feeling of the space. For shots like this, I work in AI Servo mode (continuous shooting); this improves the odds of capturing that split second when the decisive moment unfolds.

FLATTERING ANGLES

Every bride wants to look her best on her wedding day. Photographing from above is flattering for almost every bride; it tends to be slimming and puts added emphasis on the eyes and face.

Avoid posing a bride square-on to the camera. Posing her at a slight angle creates a more flattering look.

❝ I captured a series of shots of the action, but this image was my favorite. ❞

Specs

Canon EOS 1DX • 16–35mm f/2.8 lens at 16mm
f/2.8, 1/20 second, ISO 800

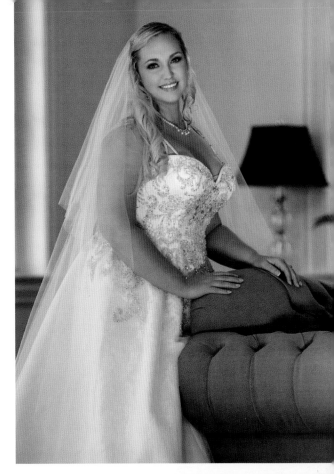

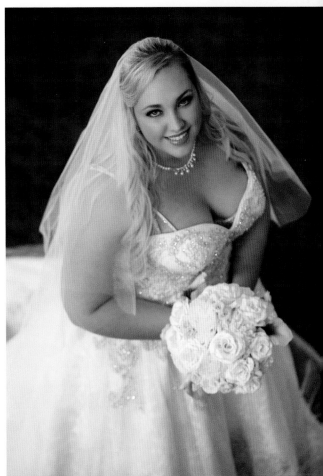

LIGHTING

For each of the three images presented in this section, a different light source was used.

For the portrait shown at the bottom left of the page, I used a tungsten video light to match the color temperature of the ambient light, ensure neutral tones on the bride's white gown, and achieve a flattering rendition of her skin tone. My assistant held the light source at camera left, close to the bride's face.

For the image at the bottom right of the page, I used a strobe to overpower the ambient light. The result is a dramatic bridal portrait with a contemporary look.

A NATURAL ELEGANCE

The featured image (facing page) is a candid portrait. I noticed the beautiful natural light behind the bride as she walked toward me. I wanted to capture the glorious detail in her dress and also document her natural elegance and glowing expression as she approached. I shot from a low angle using a 70–200mm lens at 200mm and f/4. Using a wide aperture allowed me to produce an image in which there is enough detail in the background to suggest a lush garden location, but it is soft enough that it is not distracting.

THE TEXTURE OF THE GOWN

Many bridal gowns feature ruching, embroidery, beading, or other textural design elements. To capture them, look for lighting that skims across the surface from a sharp angle.

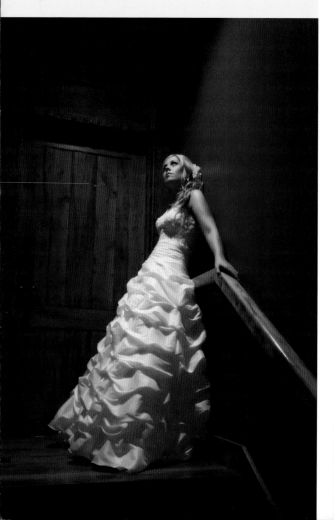

Specs

Canon EOS 5D MK II • 70–200mm f/2.8 lens at 200mm • f/4, 1/250 second, ISO 250

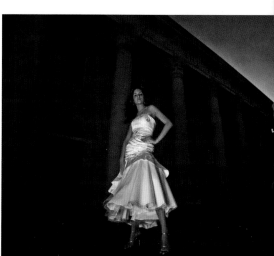

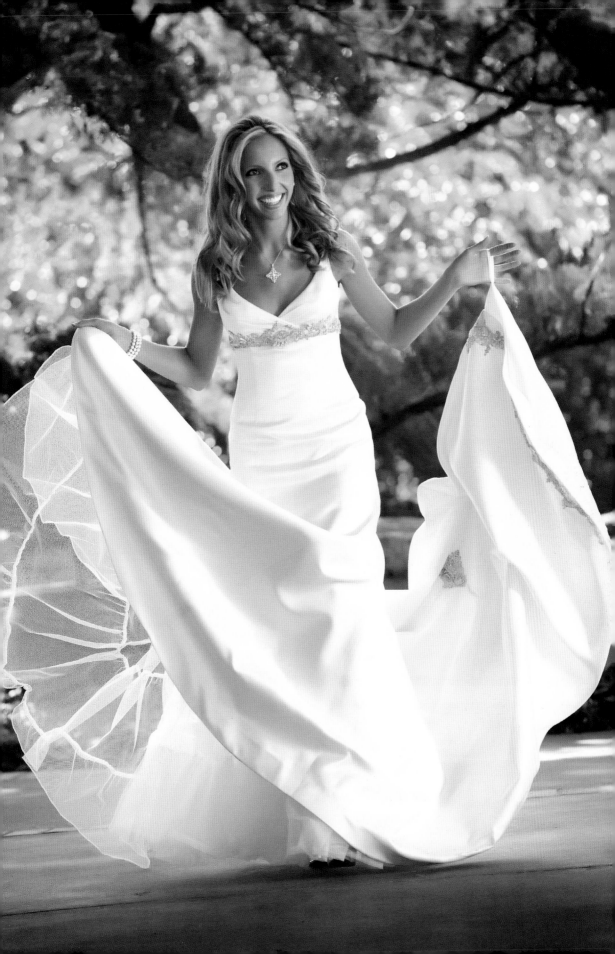

ENTERTAINING CONCEPTS

It's my goal to capture something unique for every bride and groom. If there is an aspect of their personalities that really stands out or there is something about a location that is wildly unique, I make it a point to construct an image around that element.

THE PROCESS

The image of the bridesmaids was unstaged. I walked into this room after the women had finished their hair and makeup and decided to kill a little time with a game. The scene was illuminated by the light from a large window behind the subject who was

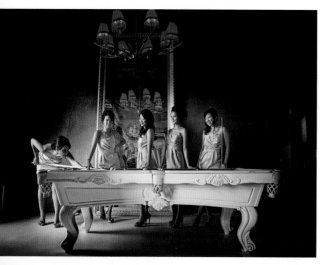

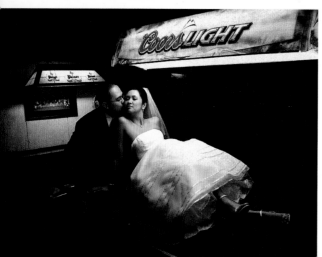

shooting; the mirror reflected some light and added interest as well. A touch of ambient light came from the chandelier, too.

I was drawn to the pool table light in the image with the bride and groom. I

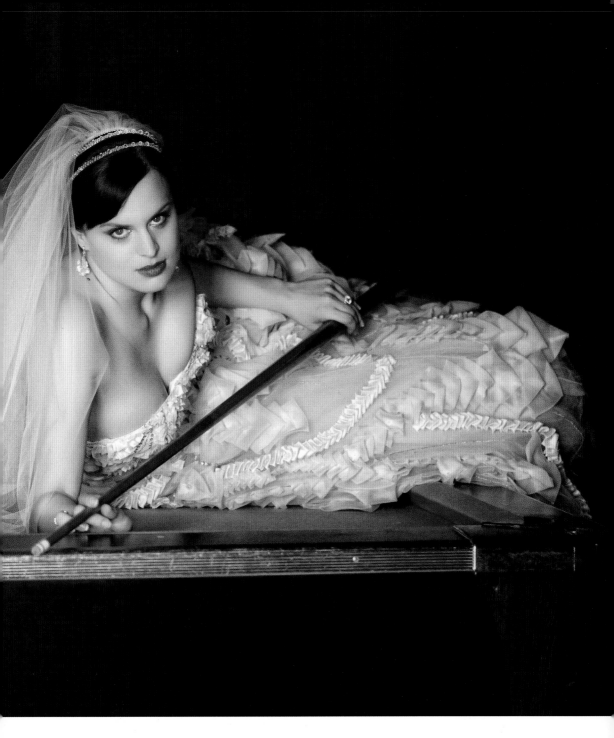

wanted to use it as my main light source, so I had the bride climb up onto the table and prompted the groom to move in close. The result is a sexy, fun image that's different from what most other photographers offer.

The bride in the main image wore one of the coolest dresses I've seen. I asked her to assume a reclining pose to show off the detail of the dress. With a sexy expression and bold eye contact, the image is a winner.

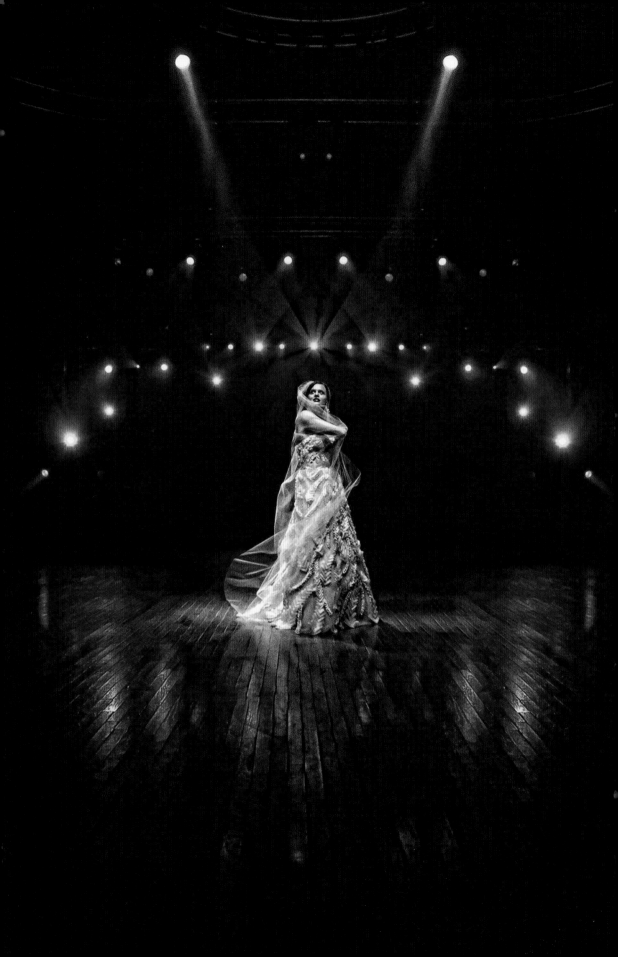

MEANINGFUL LOCATIONS

This particular image was shot on a stage. The bride's family was in the music business, so I conducted her bridal portrait session here, with every single stage light on.

LIGHTING AND MOTION

I wanted a dramatic look for this bride. I had her tilt her head up toward the spotlights above her to get good light on her face. I asked her to twirl around a bit until I found the right position.

COMPOSITION AND POSE

I opted to position the bride in the center of the stage because I wanted a symmetrical composition for this shot. Note the way the arc of lights frames the bride. Note too the beautiful reflection in the glossy wooden floor. From the leading lines of the floorboards in the foreground to the black background below the arc of light, we get a sense of depth and dimension in the portrait.

POSTPRODUCTION

I bumped up the contrast in postproduction to add a little drama to the shot and to bring out the highlights and shadows in the bride's distinctive dress.

Specs

Canon EOS 1D MK IV • 16–35mm f/2.8 lens at 16mm • f/2.8, 1/160 second, ISO 1000

❝ I had her tilt her head up toward the spotlights above her to get good light on her face. ❞

A SIMILAR LOOK

For this image, my assistant held a video light at camera right to illuminate the subject's face. The eye is drawn from the bride to the light fixture and back again due to the bright tones and similar shapes in both thirds. I burned in the non-subject areas of the portrait, effectively taking them out of the image equation.

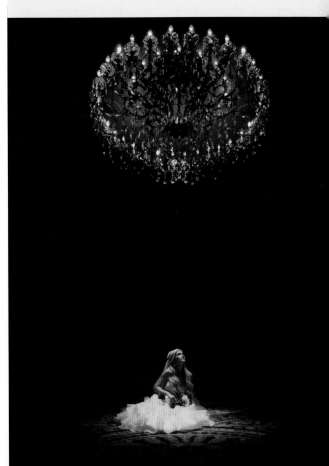

TRADITION

Henna ornamentation (Mehndi) is an important part of an Indian wedding. This bride had exquisite henna detailing on her hands. We went outside during a break between the ceremony and reception to document the elaborate artwork.

Specs
Canon EOS 5D MK III • 70–200mm f/2.8 lens at 200mm
• f/3.2, 1/1250 second, ISO 1000

DEPTH OF FIELD

I posed the bride with her hands out in front of her and used a relatively wide aperture of f/3.2. I wanted the depth of field to be shallow enough to render her face slightly out of focus behind her crisply focused hands. Viewers can still make out her

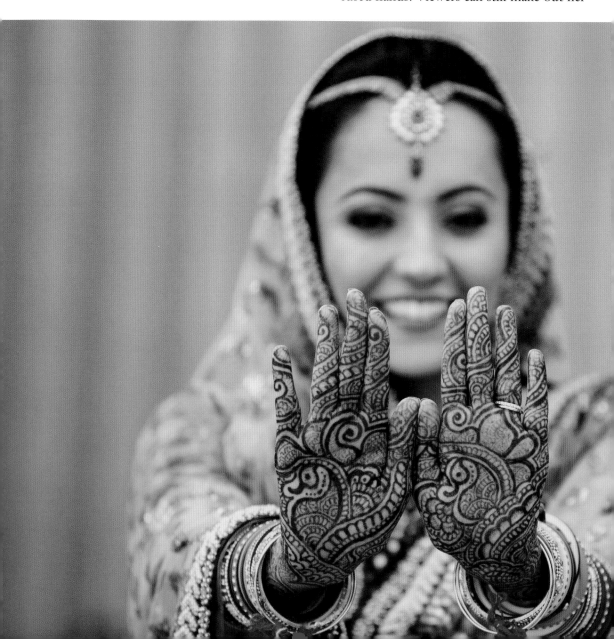

beautiful smiling expression, but the majority of the visual emphasis is on her hands.

LIGHTING

The bride was positioned under an awning that blocked the overhead light. She was illuminated by the light coming from behind me and slightly to the side.

PORTRAIT OF THE COUPLE

I try to work unobtrusively on the wedding day, as much as is possible. I want the couple to relax, be themselves, and enjoy the memories they are creating—without feeling a lot of pressure to perform for the camera. By using a long lens, I can afford the couple some private moments and still capture intimate images like the one below. In this case, the couple was out walking just after the ceremony and before the reception. I shot with my 70–200mm f/2.8 lens at 145mm and used a wide aperture (f/3.2) to blur the background and keep the viewers' focus on the contented expressions of the couple.

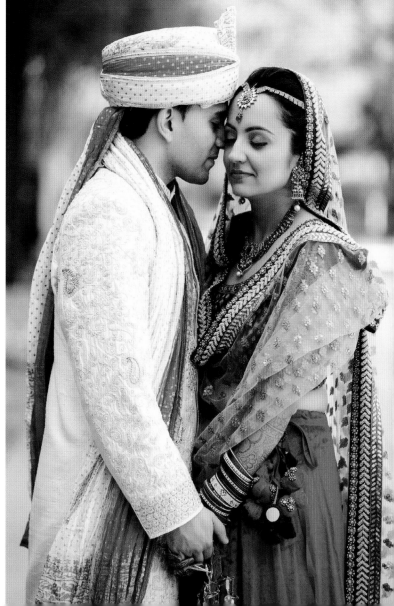

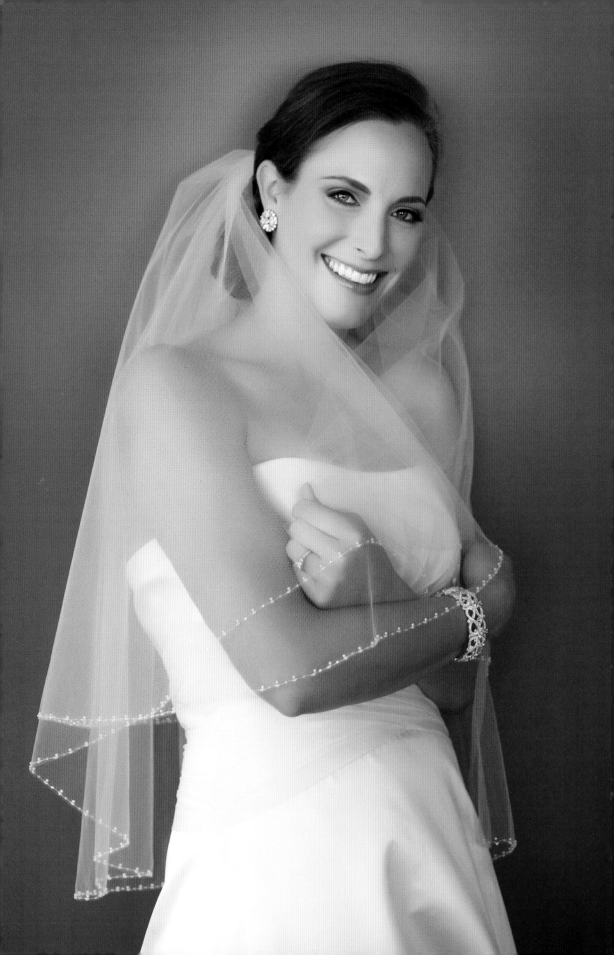

ENHANCING THE MOOD

Sometimes the weather is less than ideal for capturing bridal or wedding portraits outdoors. So, when the location that you're shooting in is somewhat featureless, try looking for bold color that will help you create dramatic portraits that your clients are sure to love.

In the venue where these images were made, there was no extraordinary detail to be featured, and most of the rooms were painted white. Fortunately, we came across a couple of areas painted in warmer, more inviting colors. In the resulting images, the tones flatter the bride and help reinforce the feeling of joy we see on her face.

With the simple background and pop of color in each image, I was able to create the fashion look that brides hire me to capture.

TWO TAKES

I shot the featured image with a 50mm lens at f/2.8, 1/500, and ISO 1600. I cropped tightly so the bride fills most of the frame.

For the second image, below, I positioned the bride between the uplights for a symmetrical effect. I think the result is a modern, clean image. The vignetted edges of the photograph help keep the viewer's focus on the bride.

66 The tones flatter the bride and help reinforce the feeling of joy we see on her face. 99

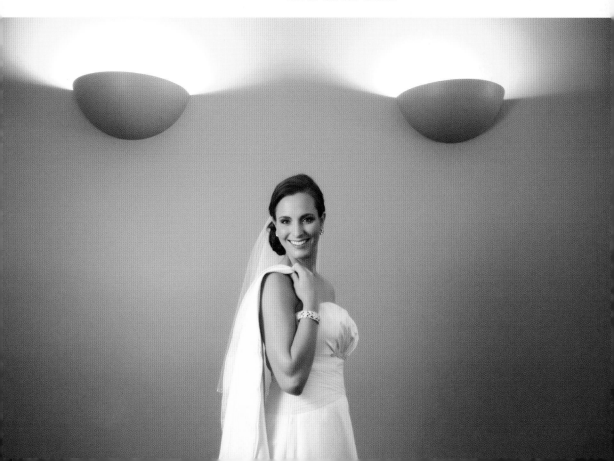

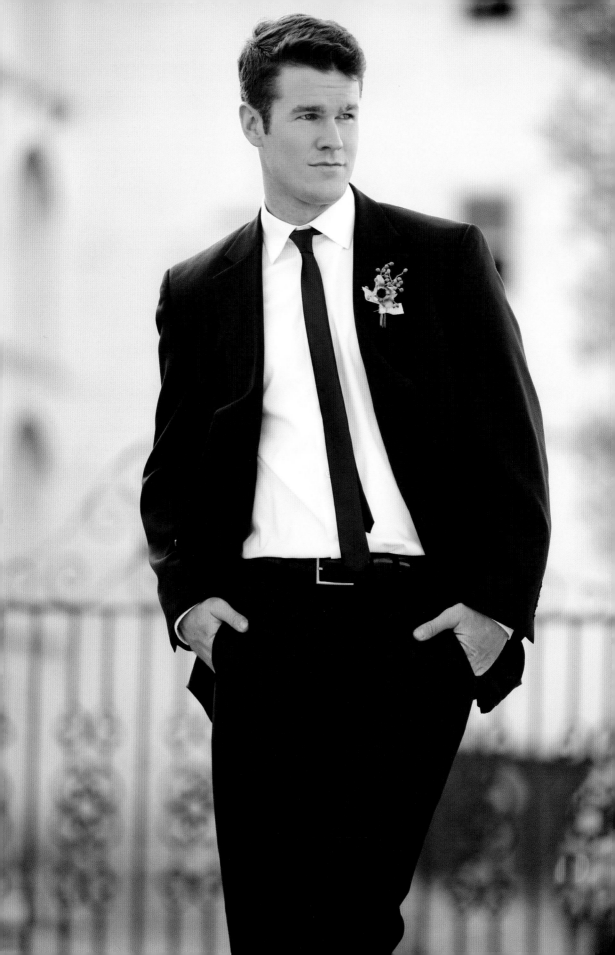

THE CAMERA-SHY GUY

It's important to take photos of the groom on the wedding day. It's a facet of photography that too many photographers overlook. While the guys may not be overly enthused about posing for pictures, the bride and the family are definitely going to want to see some shots of the men.

POSING

I like to take a very casual approach to posing men. For the image on the facing page, I had the groom unbutton his coat and cross his feet for a natural, relaxed pose. I had him place just the fingers of both hands in his front pockets, leaving his thumbs out. He looked off toward camera right. The viewer gets the impression that his thoughts are elsewhere—not on the session. The result is a photograph that has a candid, magazine-style look—which was precisely what I had in mind. The groom looks like he stepped out of the pages of *GQ* magazine.

A HELPFUL HINT

The hands are one of the trickiest parts of creating a good, strong pose. Giving a guy something to do with his hands goes a long way toward creating a natural look.

> *Specs*
> Canon EOS 1Ds • 70–200mm f/2.8 lens at 200mm
> • f/2.8, 1/2000 second, ISO 1250

LOCATION AND LIGHTING

The main image in this section (facing page) was made at South Beach in Miami. We were walking the beach together, looking for great locations for the shoot. The green bench seemed a great prop.

The portrait was captured at about 2:00PM. The natural light was anything but ideal for portraiture. Therefore, I needed the control that studio lighting affords.

I positioned my strobe—a Profoto—at camera left, just beyond the tree at the edge of the frame. I adjusted the light to full power and aimed it right at her. This overpowered the natural light and rendered the background a little darker than the subject.

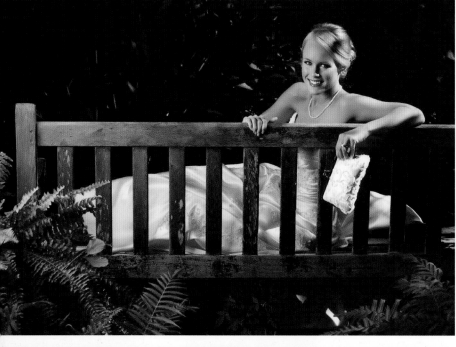

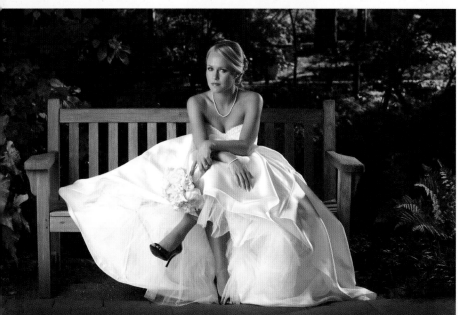

This allowed her to pop out from the background and gain prominence in the frame.

I really love the way the lighting rendered her beautiful red hair and held the tones in her dress.

THE POSE

I posed the bride with her face turned toward the main light. The lines of her arms and legs are graceful yet dramatic. This lends a fashion-like feel to the image.

VARIATIONS ON A THEME

In the supporting images (facing page)—also shot with strobe lighting—you see some posing variations that work well when photographing a woman seated on a bench. The options are nearly limitless!

Specs

Canon EOS 5D MK III • 70–200mm f/2.8 lens at 70mm • f/18, 1/125 second, ISO 160

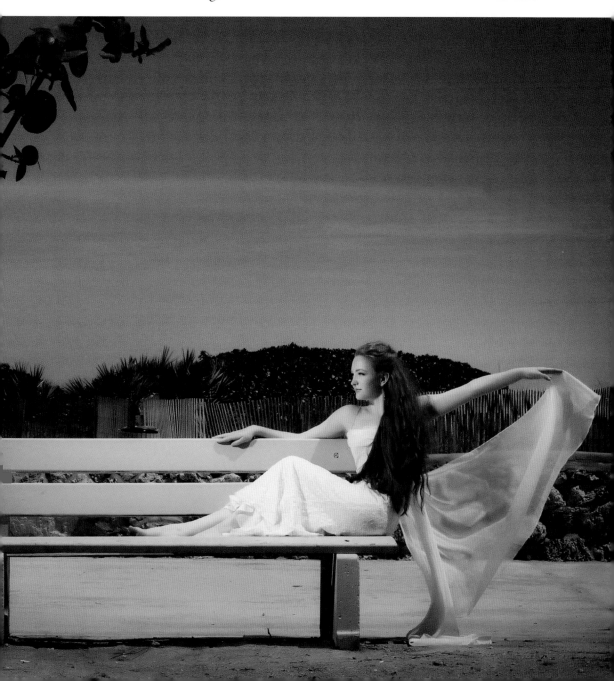

This portrait was created during a bridal session. I met the client at a hotel and we began to scout the location for interesting areas to shoot in.

A LIGHT POCKET

As we walked through the hotel, this little pocket of light spilled through the window. There were dramatic shadows of tree limbs on the wall, and the surrounding area fell into shadow. Light like this lasts only a few minutes. I knew we had to work fast to get the shot.

I posed the bride on the floor in order to ensure her face was illuminated by the window light. Interestingly enough, there was a business center with a fax and a copier behind the door she was posed against. You can't be too choosy when you find beautiful light. It simply pays to take advantage of it—while it lasts.

I had the bride pose at an angle to the window and turn her face toward the light. The subject had beautiful eyes and great hair, and the light I found here really showed them off to great effect. I added a reflector to camera right to soften the shadows.

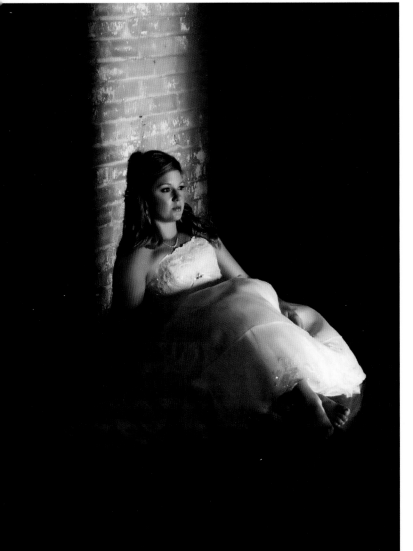

THE POSE

The skirt of the dress created a nice wide base for this pose. I had the bride lightly grasp her veil in her left hand and pull it slightly across her. This created a sense of movement in the image and also gave the bride a simple pose for her right hand. Her left hand was posed gracefully in her lap with her fingers slightly curled. The overall pose is graceful yet dramatic.

VARIATION

The same concept was used to create the image on the left.

Specs
Canon EOS 5D MK III • 70–200mm f/2.8 lens at 80mm • f/2.8, 1/200 second, ISO 1000

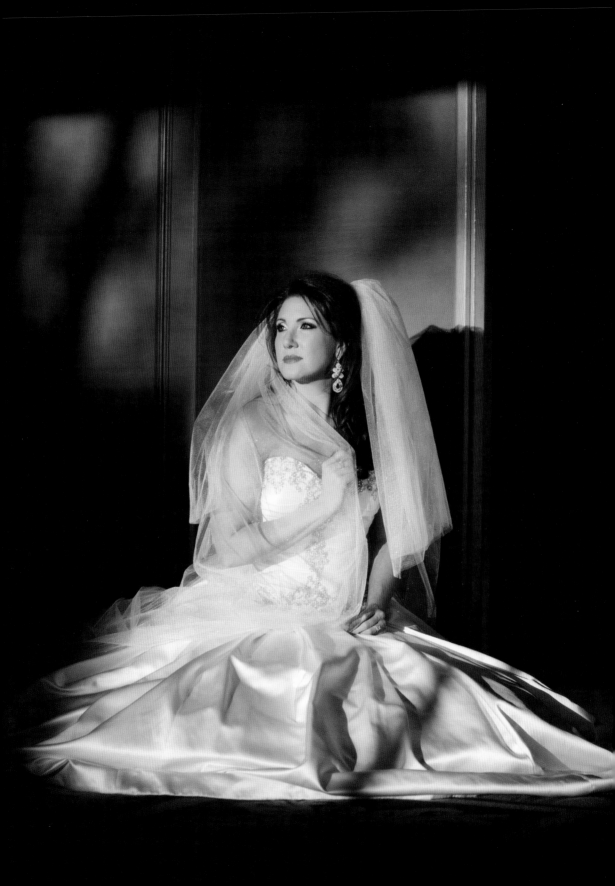

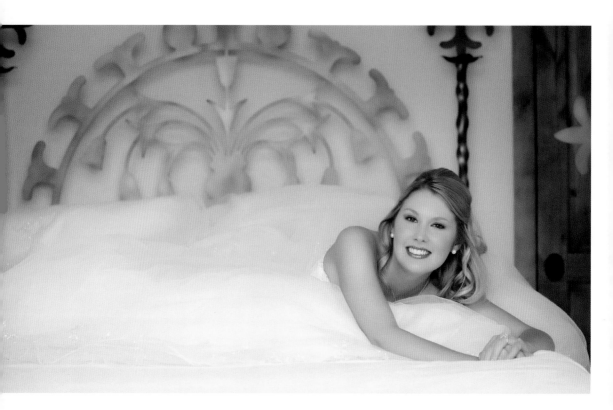

These photographs were created on the wedding day. The bride had just finished her preparations and was ready to have some fun.

GIVE HIM THE BOOT(S)

This couple's wedding was planned around a country theme, so it was especially important to the bride to have an image in which her white boots were featured prominently (facing page).

Specs

Canon EOS 5D MK III • 70–200mm f/2.8 lens at 70mm • f/2.8, 1/125 second, ISO 1250

LIGHTING AND POSING

There were large windows behind me, and I opened a door to let more light into the room. I had the bride tilt her head toward me (for beautiful, soft light on her face) and put her feet on the headboard. I stood at the foot of the bed to capture the shot. I focused on her eyes; the image falls into soft focus as the distance from the lens increases, but the boots are still clearly discernible.

A SEXY VIBE

The image has a sexy vibe; the bride's expression and the playful pose help to create a sultry feel in the image. Her eyes and lips provided a pop of color that keeps the viewer focused on her beautiful face.

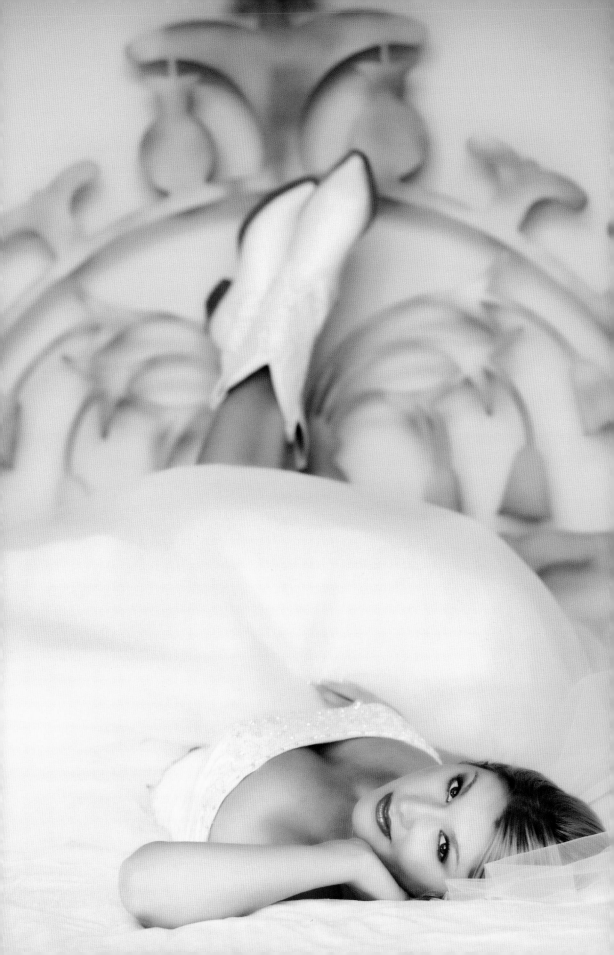

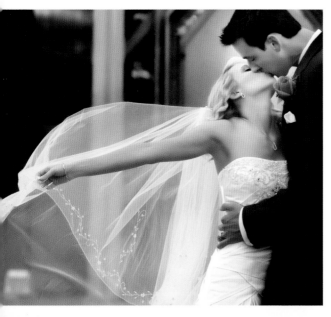

AN ELEGANT TOUCH

I love playing with veils in bridal images. It is one of my favorite parts of the session. When the weather is right, a soft breeze can lift the veil and give it life. Other times, I might have the groom help to get the veil moving. The images here are all different, but each is natural, fun, and stylish.

CONTINUOUS SHOOTING MODE

Getting a perfect veil shot in one take is highly unlikely. I always capture these images with my camera set to AI Servo (continuous shooting) mode to increase the odds that I will get a shot in which the shape of

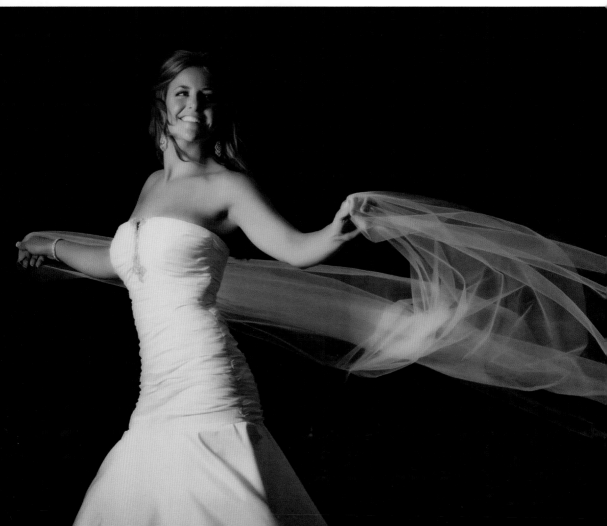

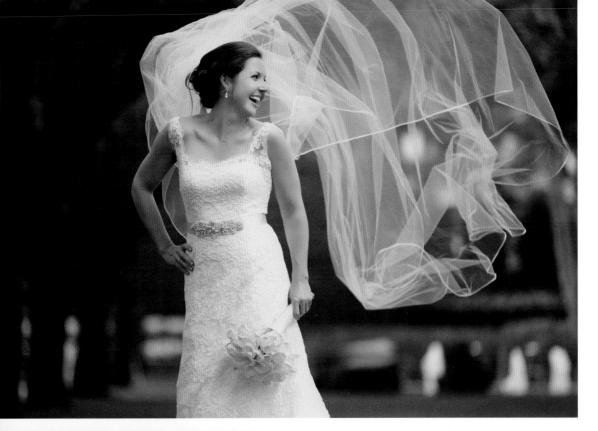

the veil is perfect and the bride's expression is beautiful.

COMPOSITION

For the biggest impact in portraits featuring brides with long veils, pose your subject with a lot of space behind her so that when the wind catches her veil, it creates a long, dynamic leading line that draws the viewers' eyes through the frame and right to the subject.

❝ I always capture these images with my camera set to AI Servo mode. ❞

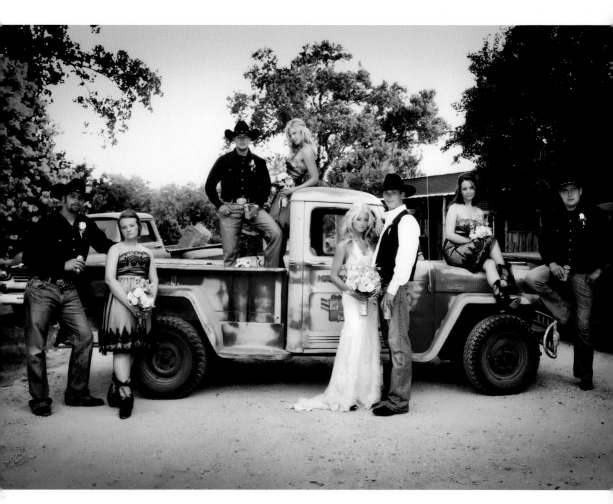

MORE PLAYTIME

This image was made on a ranch in Waco, TX. The wedding party was small. There were three bridesmaids, three groomsmen, and the bride and groom. I love photographing small parties. When there are a smaller number of subjects, you can take a little more time to play around with the portrait concepts, as you are not worrying about getting so many people into the frame, positioned, and posed.

THE COMPOSITION

This old truck was found at the location. I knew it would make a great prop and would help to document the theme of the wedding. I positioned one wedding party couple near the tail end of the truck, another

Specs

Canon EOS 5D • 16–35mm f/2.8 lens at 20mm • f/6.3, 1/200 second, ISO 1000

by the cab (with the woman on the roof), and the third near the front end. The bridal party created a nice triangular shape in the composition. Finally, I posed the bride and groom near the passenger-side door, turned slightly toward each other and facing the camera. Each of the four couples looks great and there is equal distance between them. Every subject's pose is different. The eye travels over the arc comprised of the wedding party couples, then circles back to land on the bride and groom, the focal point of the portrait.

LIGHTING

This image was made in early evening using natural light only. No reflectors were used.

PLAYING AROUND

Ranch weddings are popular in many parts of the United States. Look for unique location features that will allow you to flex your creativity. In this case, there were three swings—and luckily, three bridesmaids—so I opted to create a composition with the bridal party seated and the bride standing prominently in the left third of the frame. In another image, I included cattle in the frame. Hey—what better says "ranch" than a cluster of cows?

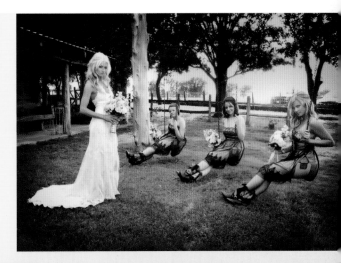

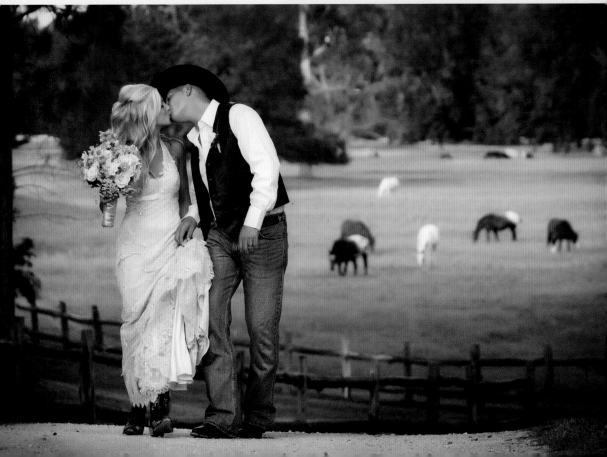

THE BRIDAL PARTY

I photographed this bridal party in Oklahoma at roughly 30 minutes before sunset. The sun was directly behind this row of trees, and it created gorgeous highlights on the women's hair. The background was quite dark in comparison, so the contrast ensured good background separation across the group.

This image was made with all natural light.

AN IMPORTANT PERSPECTIVE

Golden hour light is perfect for romantic portraits. It flatters your subjects' skin and casts soft shadows that model their forms and faces.

To create the featured image (facing page), I carefully composed my image so that the subjects' heads were positioned against a dark portion of the background. If I had shot from a lower angle, the beautiful highlights in the subjects' hair would have been swallowed up by the bright sky.

OVEREXPOSURE

I intentionally overexpose my backlit images to ensure that there will be enough light on my subjects' faces.

> ❝ From a lower angle, the beautiful highlights in the subjects' hair would have been swallowed up. ❞

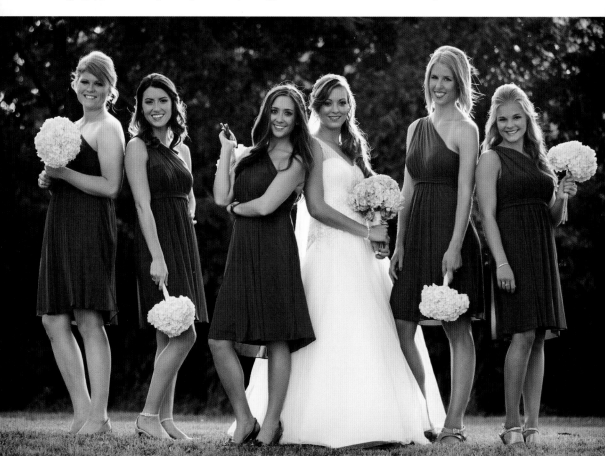

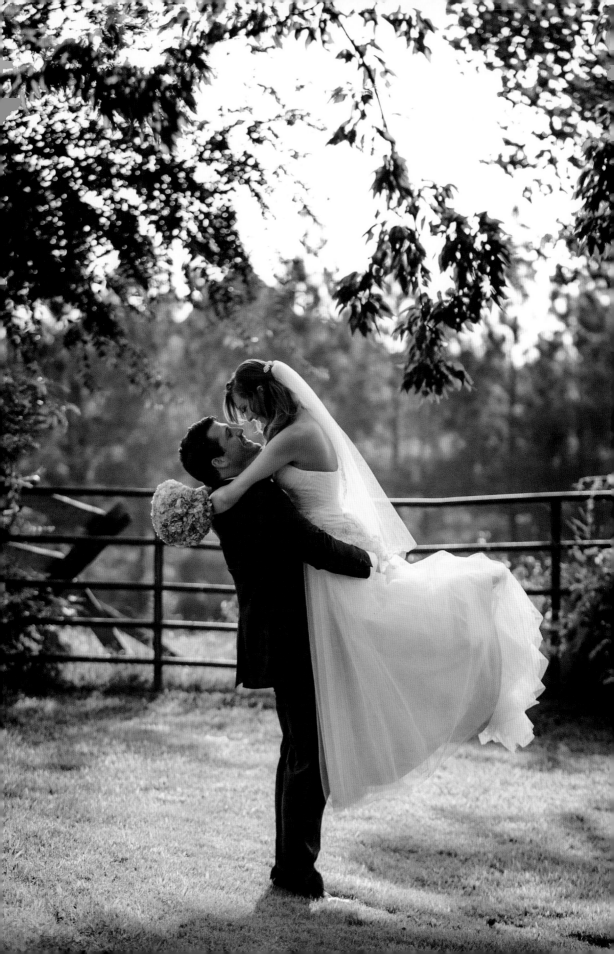

NOT SO SERIOUS

As the images here show, when photographing wedding groups, it pays to experiment and have some fun.

For the image below, we were out shooting on the wedding day and it was raining a little bit, so each of the ladies had an umbrella handy. When we got to these steps, I planned to do a more straightforward shot of the girls in their dresses, but we came up with another idea. The women wanted to cover their dresses with their umbrellas to create the impression they were nude. The result is a funny and sexy take on a classic bridal shot. It has also been very popular on Pinterest—many photographers have wanted to copy it with their own clients.

COMPOSITION

For the umbrella shot, each of the bridesmaids was posed on a different step in an arc surrounding the bride. The dark umbrellas create strong contrast to the white dress and draw the eye to the focal point of the shot—the "blushing" bride.

THE CAPTURE

I shot this image on aperture priority mode. I took a couple of shots with the camera in AI Servo mode to ensure continual focus because the subjects were moving around a little bit and it was windy. The day was overcast, and the image was captured with all natural light.

Specs

Canon EOS 5D MK II • 70–200mm f/2.8 lens at 85mm • f/4, 1/125 second, ISO 1600

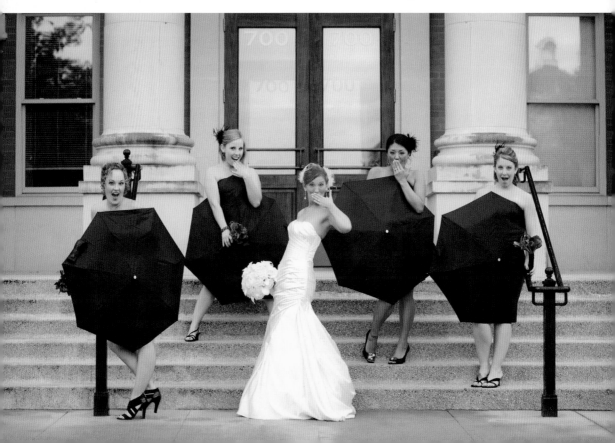

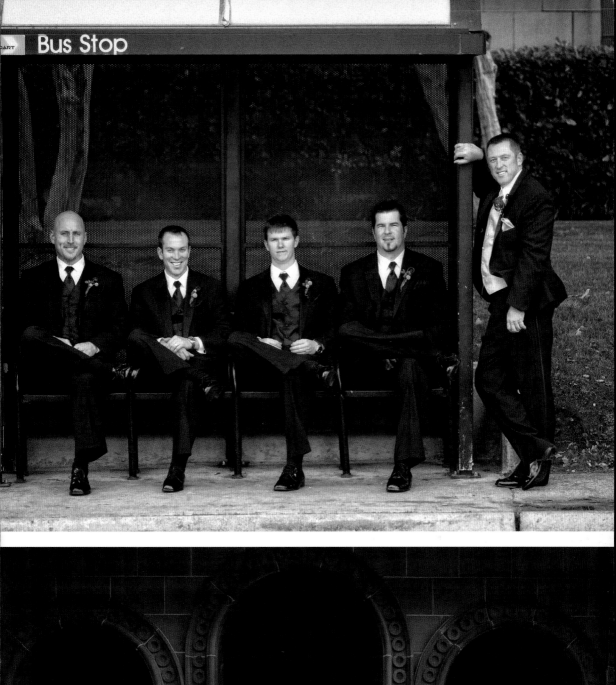
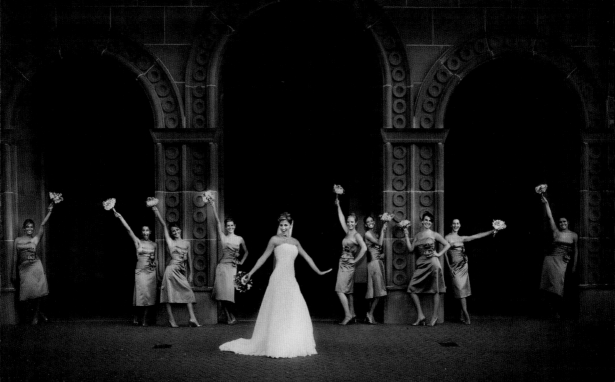

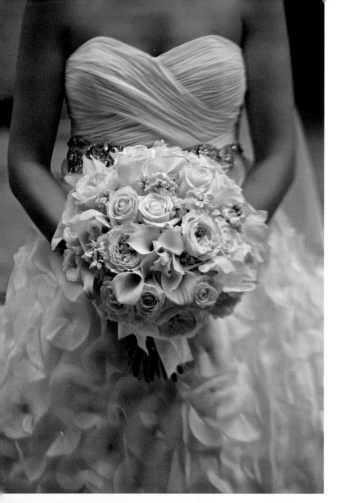

HER SIGNATURE

The bouquet is an iconic part of the wedding day. Be sure to get images of the bride with her bouquet, and also get close-up shots in which the bouquet is the focus of the image.

MEMENTOS

Many brides include in their bouquets special mementos that memorialize loved ones. When you see a bouquet that includes more than just flowers, get a close-up of the special detail. It's a gesture the bride is sure to appreciate.

AN AWARD-WINNING IMAGE

The image on the facing page won first place in WPPI's Wedding Details category. I liked the tic-tac-toe grid pattern in the window, so I added a texture overlay onto the image. The added texture adds a rustic look.

❝ I opted to composite the bouquet image with a photo containing a distressed wall. ❞

Specs

Canon EOS 5D • 24–70mm f/2.8 lens at 28mm • f/2.8, 1/160 second, ISO 1000

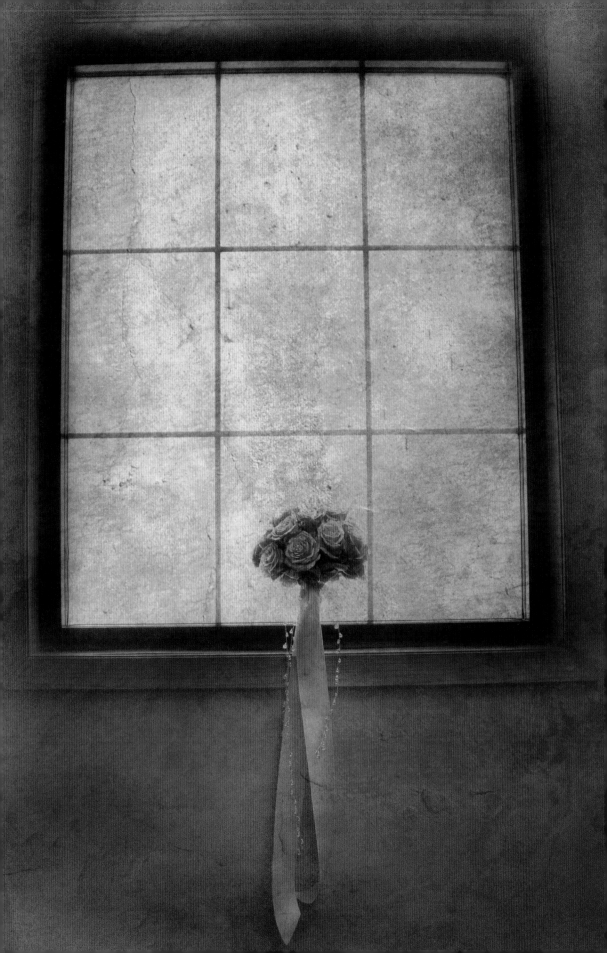

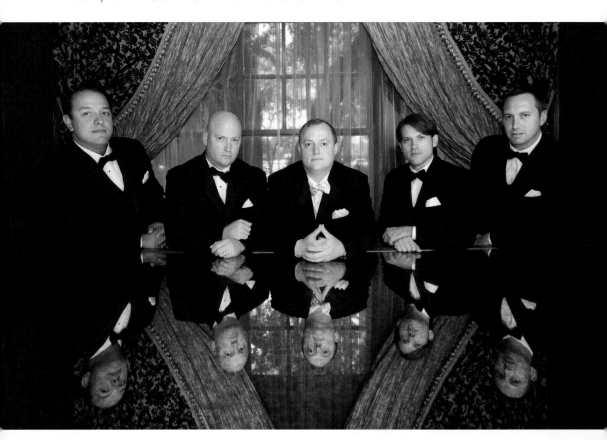

THE CONCEPT

The image above was captured before the ceremony, at the hotel bar. The guys were just standing behind this table. I decided to do something that mimicked the mood in the film *The Godfather.*

COMPOSITION

I posed the men with the tallest guys on the edges of the shot. Everything about the image is somber and serious, from the formal hand poses to the straight-faced expressions.

I love the reflection in the table. Every shape in the image—from the arc formed by the subjects' positions to the triangle in

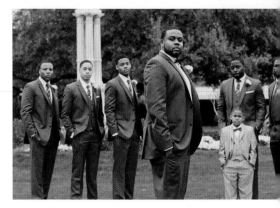

Specs
Canon EOS 5D MK III • 16–35mm f/2.8 lens at 16mm • f/8, 1/200 second, ISO 800

the gold of the drapes—directs the viewer's gaze through the image. The symmetry that was created in the image helps to project the classical, more stiffly posed feeling in this portrait. It's a one-of-a-kind image.

LIGHTING

I used a Canon Speedlite off camera at 1/64th power at camera right. It was feathered across the subjects to add light on their faces and create a balanced exposure.

POSING THE MEN: STRONG AND SOLID

Sometimes I go for a *Reservoir Dogs* or *Ocean's Eleven* look when photographing men. It's a style they appreciate. I typically place the groom in front of the group and position the other men more in the background. This creates a feeling of depth and adds a dynamic feel in the image.

The groom in the image at the bottom of this page was a Dallas Cowboys running back, and his party was made up of NFL players. For this shoot, we went for an MTV *Cribs* look.

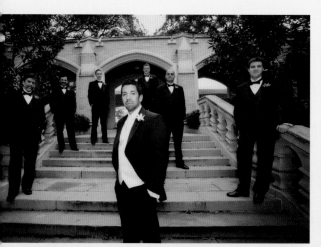

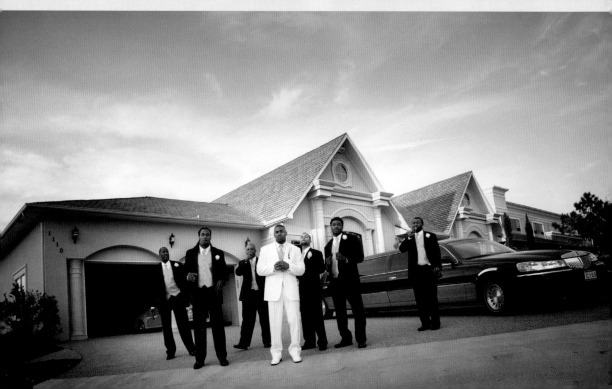

SETTING THE SCENE

This wedding was held at a beautiful old church in Chicago, IL. I wanted to capture an image that had a sense of fun to it. I really like this image. It is one of my favorites from the wedding.

THE POSING

All of the women were posed toward camera left, and all of the men were posed to camera right. The wedding party formed a loose cluster behind and around the bride and groom, and each subject struck a unique, fun pose. The bride and groom are lost in a kiss, seemingly oblivious to the outburst of joy around them.

The lines of the entryway frame the group, and the lines of the steps seem to contain the entire wedding party. This

> ❝ The wedding party formed a loose cluster behind and around the bride and groom. ❞

Specs

Canon EOS 1DX • 24–35mm f/2.8 lens at 16mm • f/6.3, 1/160 second, ISO 1600

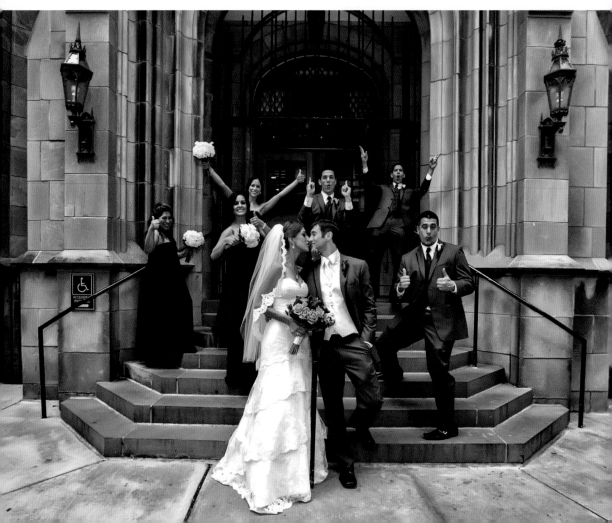

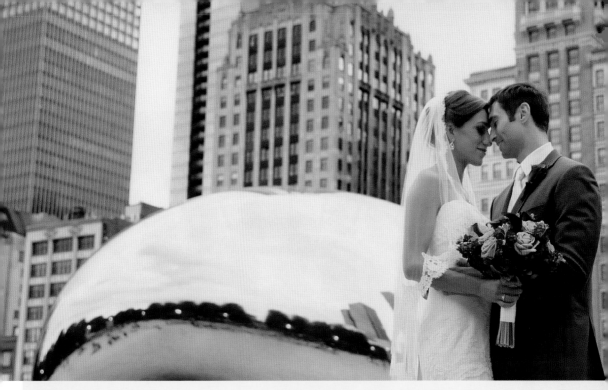

POINTS OF INTEREST

Millenium Park is home to a metal sculpture known as *The Bean* (pictured in the image above). Given the opportunity, always incorporate image elements that provide viewers with a sense of the place where the wedding day's action unfolded. It adds a layer of interest and importance to your images.

The bride's windswept veil and Chicago's towering buildings lend a contemporary feeling in the image on the right.

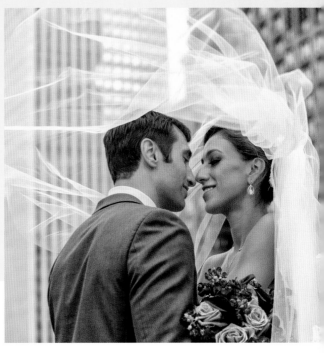

helped to produce an added level of visual separation between the couple and the attendants celebrating behind them.

LIGHTING

I used an off-camera flash at camera right to add a little fill, opening up the shadows for a flattering look.

POSTPRODUCTION

I did some toning in postproduction to increase the contrast and bring out the lines in the building.

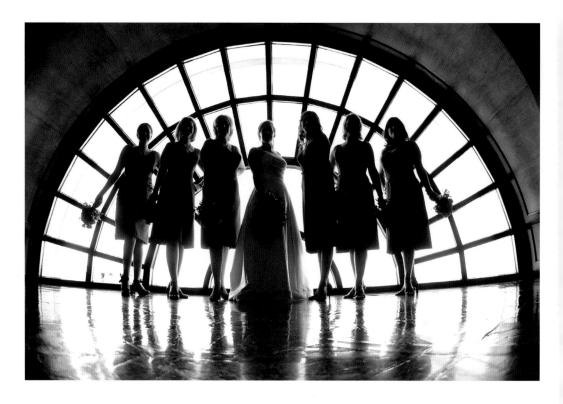

WINDOW ON THE WORLD

There was no passing up an opportunity to capture an image in front of this window. I loved its graphic qualities and knew right away that I wanted to expose for the highlights and render the party almost in silhouette. I used a wide angle lens, prompted the subjects to strike dramatic poses, and converted the color capture to black & white for added dramatic impact.

YOU'D BETTER SHOP AROUND

My bride and groom needed to make a quick stop at a store after the ceremony. It struck me that it would be a lot of fun to get some shots of the groom pushing her down the aisle in a cart. My assistant held a flash on camera left and I set my camera to rear-curtain sync for the capture. This allowed me to keep the subjects in sharp focus and blur the freezers in the background to show motion.

THE ALMA MATER

The bride and groom in the image on the right were cheerleaders at their school, and the location held lots of memories for them. I don't typically do jump shots anymore—I think they are overdone—but in this case, capturing the group while airborne helped to tell the couple's story.

A NICE CONTRAST

Grand architecture is wonderful, but more everyday locations also provide an interesting sense of contrast with the wedding finery, revealing some of the fun of the day.

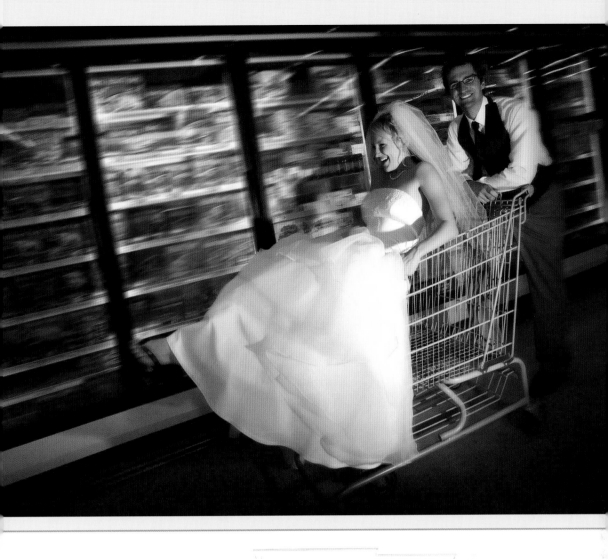
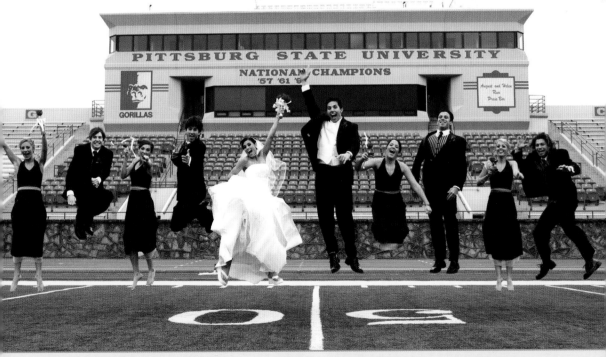

A GREAT STORY

The image below was taken in a parking garage. We had planned to leave the car here before heading over to a more scenic location—a local park—to make some portraits. This lot was empty and dark, and I thought it would make for a great backdrop.

I laid plastic sheeting on the cement to protect the bride's dress and keep it clean, and then I asked her to strike a sexy, reclining pose. The groom assumed a casual pose with one leg bent and the other leg stretched toward the opposite edge of the frame. There are great leading lines in the image. Note too that there is an implied line between the fingers of the groom's hand and the bride's hand.

LIGHTING AND POSTPRODUCTION

I keep a large, powerful 1000 watt flashlight in my car and brought it out to light the couple. My assistant held the light at camera left to illuminate their faces.

I added sepia toning in postproduction.

> *Specs*
> Canon EOS 5D • 70–200mm f/2.8 lens at 70mm • f/2.8, 1/180 second, ISO 1000

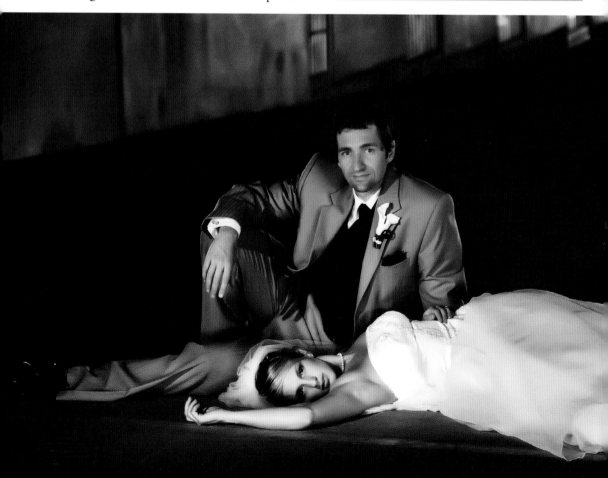

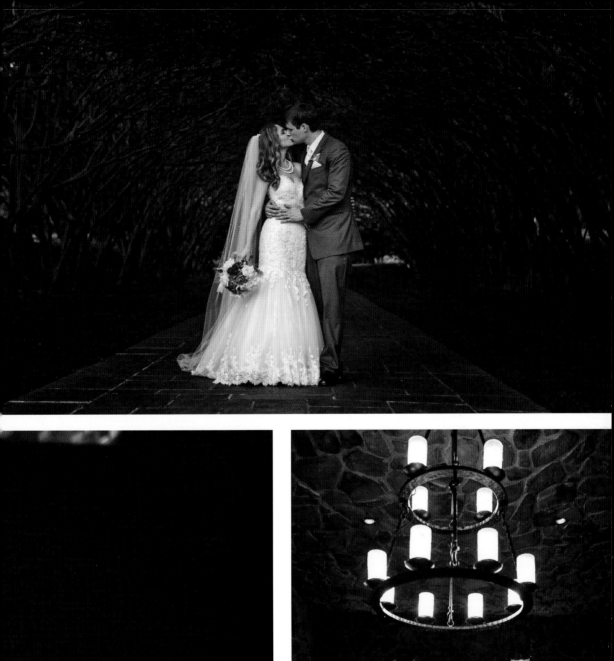
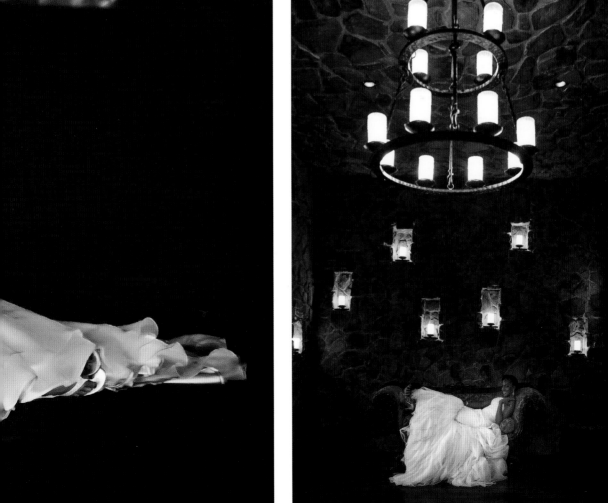

THE VIBRANT SKY

A gorgeous beach makes a great backdrop for a romantic wedding image. In this case, the images were made on the wedding day in the Caribbean.

COMPOSITION

For the sunset portrait, the couple is positioned at the right one-third line, with their faces at the upper-right power point. Notice that I positioned my camera to allow their faces to be framed by the brighter part of the sky, with no dark clouds cutting behind them to detract from their faces.

LIGHTING

My assistant held a video light to camera left to illuminate the subjects' faces. The

> 66 A gorgeous beach makes a great backdrop for a romantic wedding image. 99

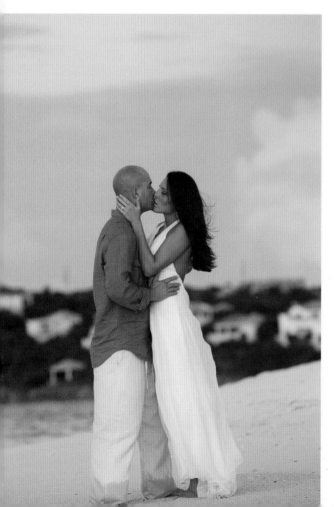

light falls off, ensuring that the viewer's attention is directed at the focal point—the couple's romantic kiss.

There was little postproduction work needed to finish the image; the colors, in nature, were almost as vibrant straight out of the camera as they appear in the final image. I added a touch of toning and cropped the portrait a little bit to produce a stronger composition. With the couple positioned at the right third of the image, the negative space on the left two thirds of the frame draws the viewers' gaze across the image and allows it to rest on the subjects.

Specs

Canon EOS 5D • 70–200mm f/2.8 lens at 70mm • f/2.8, 1/500 second, ISO 1000

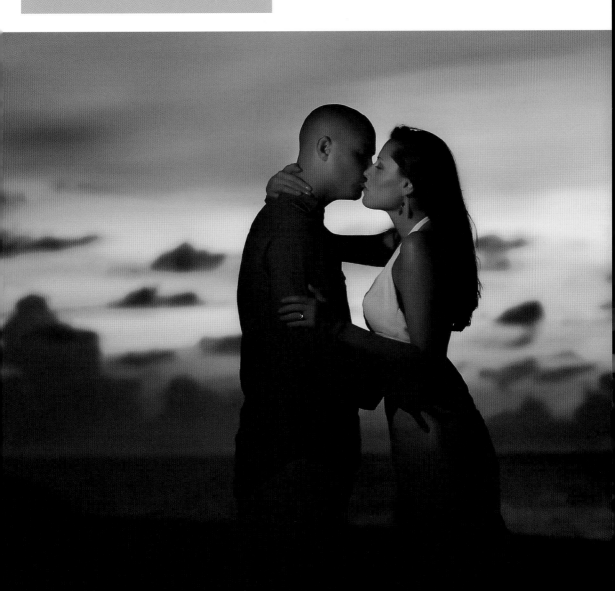

AN INTIMATE POSE

The image below features the same couple that was shown in the previous section. This image was shot on a little island called Anguilla. The couple wanted some sexy images made on the beach. The bride reclined in the sand, and the groom posed over her, kissing the right side of her neck; this allowed me to keep her profile in full view in the image. I waited until the water washed up on the shore to capture the shot.

THE DAY AFTER

"Day after" sessions have become popular among today's couples. These sessions allow you more time to craft high-quality photographs, without the couple worrying about abandoning their guests. They also allow for some risks—like a wet dress, in this case—that just wouldn't fly on the wedding day.

THE LIGHTING

We shot during the golden hour to get that beautiful, warm, golden light. The sun was behind me. Note the beautiful light that is falling on the bride's face. She is all aglow, and her expression tells us she is lost in the moment.

Specs
Canon EOS 5D • 70–200mm f/2.8 lens at 78mm • f/3.5, 1/1600 second, ISO 1000

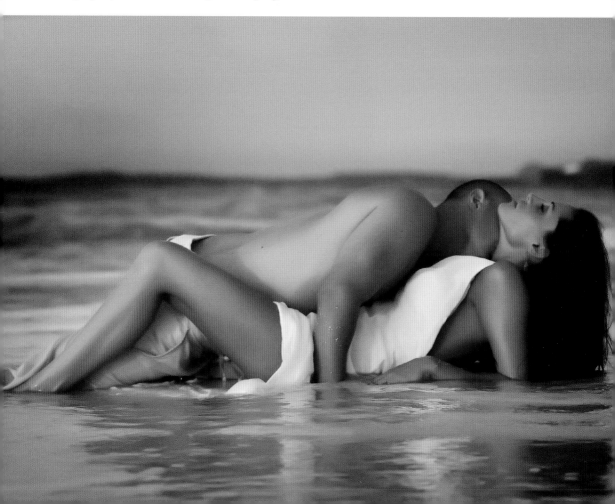

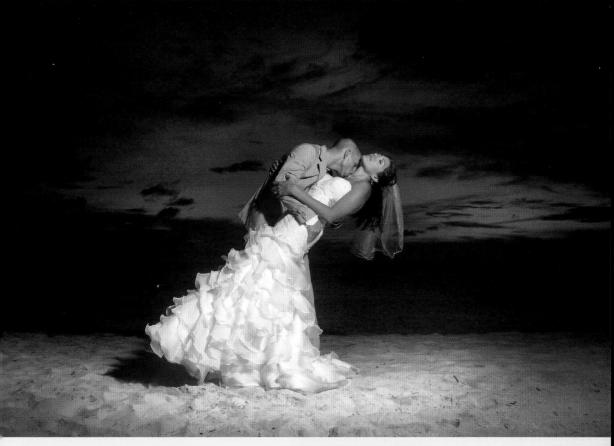

TWO MORE POSES ON THE BEACH

To light the image above, I used a Profoto strobe with a parabolic reflector at camera right. Introducing the strobe allowed me to bring out all of the colors in the sky. If I had used a speedlight, I'd only have gotten light on the upper part of the couple's bodies. With a bigger, more powerful light, I was able to light more of the image area and get detail in the clothing and on the sand, and bring out the color and texture in the scene.

Both images show a nice pose (one that's not *just* for the beach!). For the image above, I had the groom dip the bride to create some drama. For the image on the right, I had the groom kiss the right side of the bride's neck to create a romantic vibe without obscuring her beautiful face.

THE CONCEPT

The image on the facing page was shot in Portland, OR, in a cigar shack. I loved the light fixture and thought that this would be a great place to position a bride and groom for a romantic photo.

AN OVERHEAD LIGHT

The dramatic lighting in this outdoor portrait came from a canned light. I asked the groom to dip the bride to ensure her face was properly lit.

Specs

Canon EOS 5D • 16–35mm f/2.8 lens at 25mm • f/2.8, 1/30 second, ISO 1600

POSING AND COMPOSITION

My instructions to the couple were simple. I had the groom sit and asked the bride to sit on his lap and tip her head back slightly so that her face would be turned toward the light. I asked the groom to kiss the bride's neck and instructed her to place her left hand behind his head. The moment looks natural and the composition keeps the viewer engaged. The eye travels between the bright light and the subjects' faces and follows a circular patch along the bride's arm and up to the couples' heads.

LIGHTING

My assistant held a video light at camera left to supplement the existing light from the overhead bulb.

The light from above had a reddish hue. This helped create a sultry look in the image.

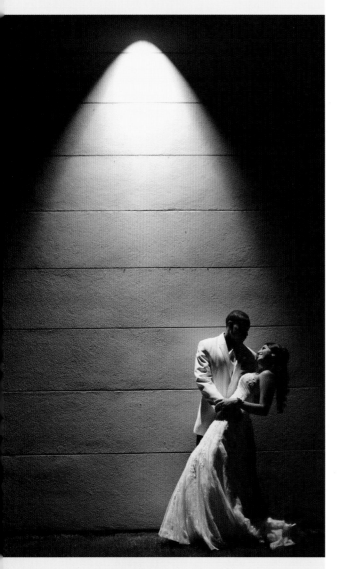

“ The light from above had a reddish hue. This helped create a sultry look in the image. ”

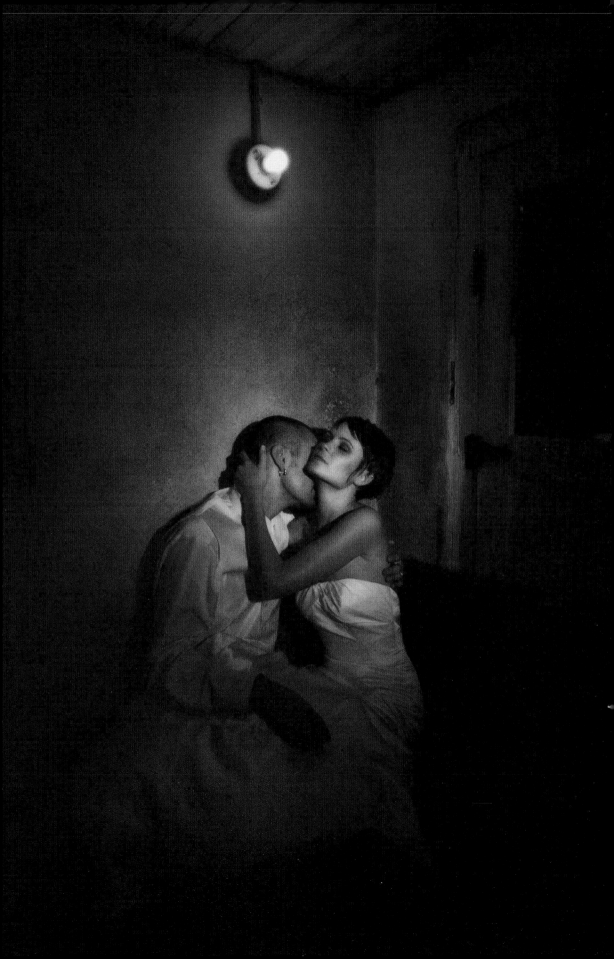

THE STORY

The bride, groom, and I were walking around after the wedding, looking for places to shoot couple photos. We came upon a

Specs

Canon EOS 5D MK II • 70–200mm f/2.8 lens at 200mm • f/4.5, 1/500 second, ISO 1250

dark alley and found a building with an orange wall. I thought it would make a good background for the shot.

THE BRIDE

The bride wore a birdcage veil (also seen in the images to the left, from other parts of the wedding day). This was a great ingredient for a romantic, dramatic portrait. Her eyes are striking and immediately draw viewers into the portrait.

... AND THE GROOM

In many of my portraits, the groom serves as a sort of a prop for the bride. As you've noticed in other images, his face is often obscured, leaving viewers to focus primarily on the bride, her emotion, and her story.

Although the bride is the centerpiece of many photos, it's important to make sure to capture photos of the groom alone and interacting with the bride, attendants, and guests. Strive for a well-rounded, complete range of images to keep everyone happy and maximize sales.

THE LIGHTING

The light for this image was all natural. I posed the couple under an awning to block the sunlight from overhead and make the light more directional.

WALKING THE LINE

I photographed this bride and groom on a deserted highway. The painted yellow lines lead the viewers' gaze to the couple's affectionate kiss. I wanted to create an image with a dramatic, fashion-forward feel, so I shot low to the ground using a 16–35mm wide angle lens. The couple occupies the center of the frame; in making that decision, I purposefully broke one of the rules

> ❝ I wanted to create an image with a dramatic, fashion-forward feel. ❞

of composition. This furthers the defiant, fashion-like feeling of the image. With their central placement in the frame and my low shooting angle, the bride and groom appear larger than life. It's a fun, unexpected image.

EMPHASIZING TEXTURE

Finding directional light is a must if you want to emphasize texture in your images. Look for light that skims the surface of the element you want to feature.

Texture is important to both of these images. In the facing-page shot, the texture is harder, more graphic. In the bridal portrait, it adds subtle interest to the bold purple wall, without competing with the detail in the dress.

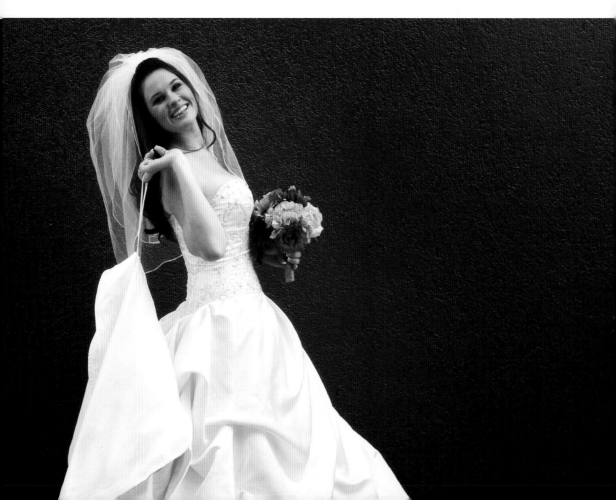

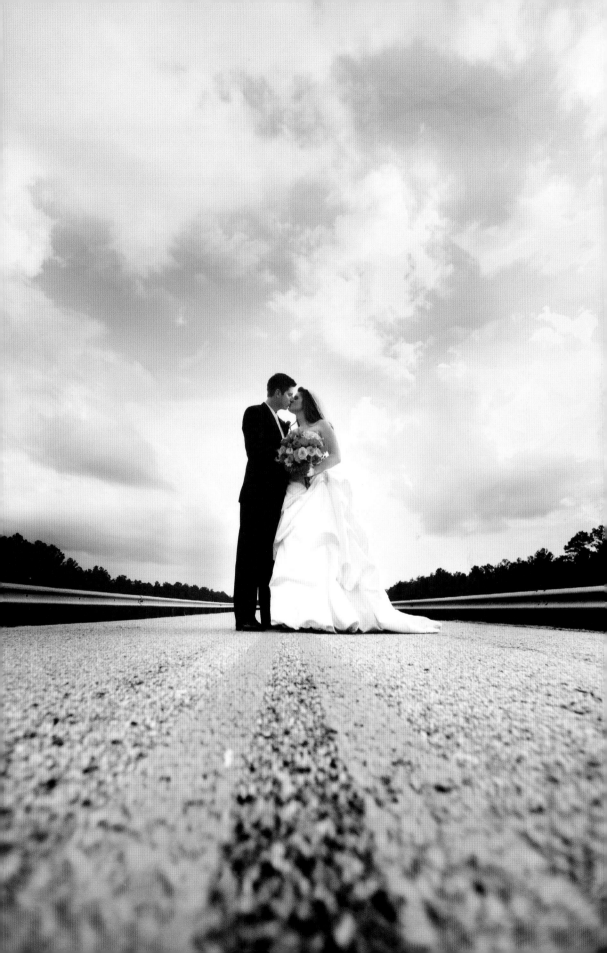

When you have strong backlighting—whether from the sun (bottom image) or flash (facing page, top)—don't miss the chance to shoot some silhouette images.

THE COUPLE AT SUNSET

For the image below, I positioned the subjects so that the late-day sun was directly behind them. There was just enough light left in the sky to preserve a touch of detail on the bodice and the skirt of the gown. You can also see the sheer texture in the bridal veil.

Specs
Canon EOS 5D MK II • 70–200mm f/2.8 lens at 70mm • f/3.5, 1/800 second, ISO 200

POSING

When posing a couple for a silhouette, it's best to keep space between their forms so that each individual can be clearly made out in the final image. (Obviously, that's not possible to control with altar shots, as shown on the facing page). In the image below, note that rather than having the couple kiss, I had them lightly touch their noses together. This gesture created a feeling of intimacy without detracting from the lines of the image.

❝ Rather than having the couple kiss, I had them lightly touch their noses together. ❞

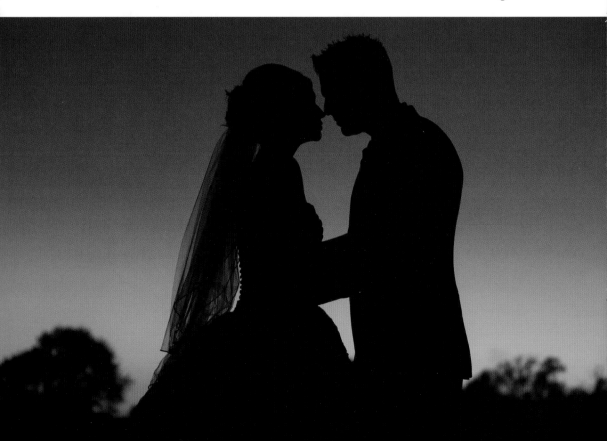

SILHOUETTES MADE WITH ARTIFICIAL LIGHT

For the portrait of the couple under the umbrella (top right), my assistant crouched below and behind the couple and held a speedlight. This created a beautiful rim light on the couple's faces. Here, as in the image on the facing page, I ensured there was enough separation between their faces to allow for a good profile presentation.

This image just goes to show that you don't need to work in natural light to offer your clients a silhouette image and create additional looks for their album.

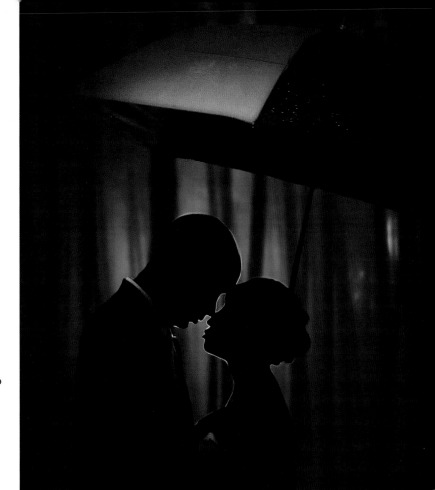

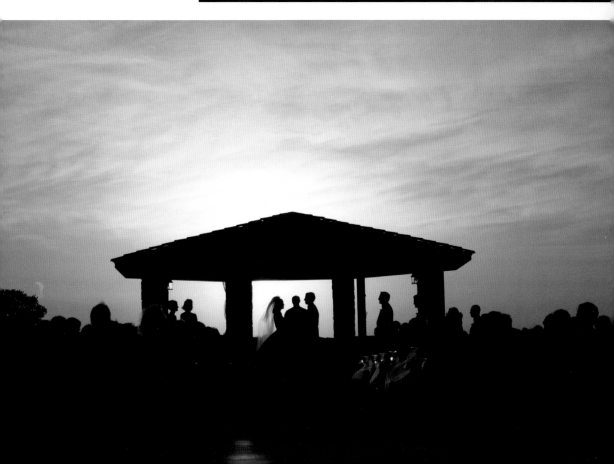

CONCEPT AND COMPOSITION

Using a long lens (70–200mm, f/2.8 at 190mm), I photographed this couple from a high vantage point on the roof of a park-ing ramp. The couple were good sports. They went out into the middle of the street when the crossing sign said "walk" and retreated to the sidewalk with every "don't

walk" command. They did this several times before we got this shot.

The monochromatic palette and graphic elements harmonize beautifully with the tenderly embracing couple. The lines draw attention to the subjects by virtue of their position in the frame.

LIGHTING

This image was made with all natural light. It was a fairly bright day, so I used an aperture of f/7.1 and shot at 1/125 second (ISO 160) to restrict some of the light entering the lens.

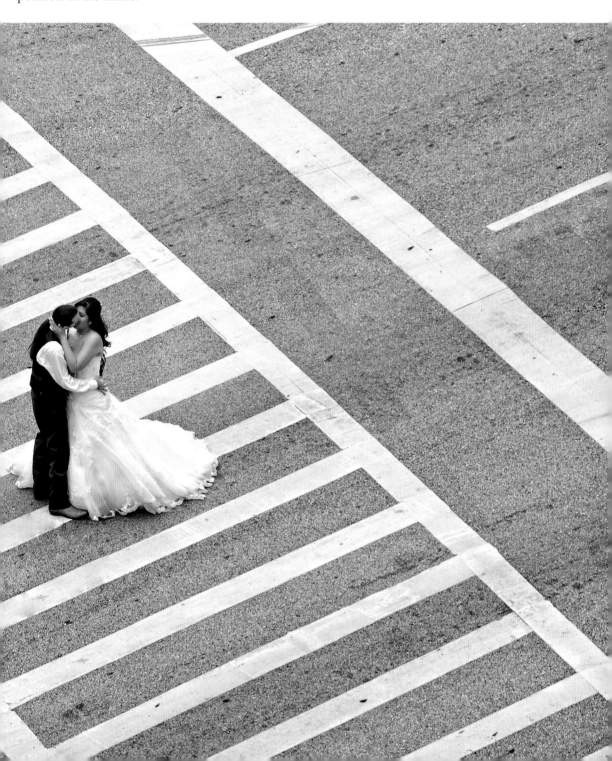

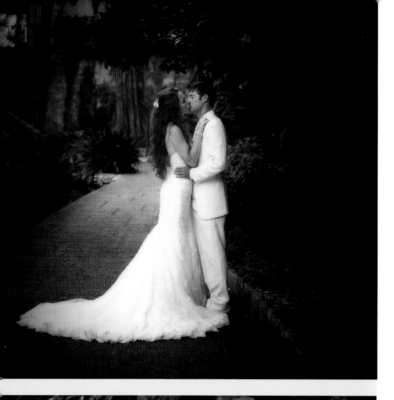

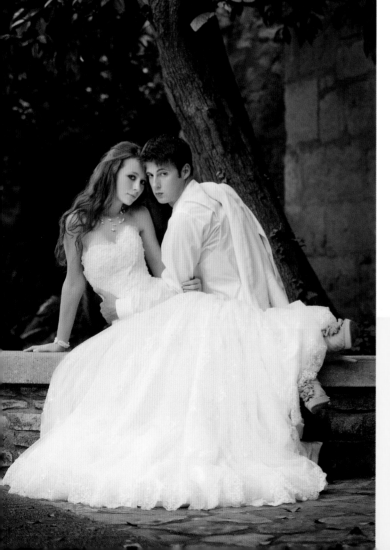

FRAMING

These images were taken on the River Walk in San Antonio during a day-after session.

I am a big believer in framing my subjects. In the image on the facing page, the overhanging branches of the tree and the sweeping curve of the walkway draw the eye to the couple and their display of affection.

I asked the groom to pick up the bride. The result was a classic, romantic pose.

LIGHTING

The trees blocked a lot of overhead light, resulting in softer, more directional light.

BACKGROUND

There was a great deal of background interest in this location. To keep the focus on the couple, I chose a long lens to compress the subject-to-background distance and used a large aperture to render the foliage, stone wall, and water somewhat de-focused.

A NICE VARIETY

Simply by exploring the available scenes and experimenting with poses, we were able to create a nice variety of images and moods, from playful to romantic.

BRIDAL SESSION ADVANTAGES

These images were made during a bridal session, which took place one to two months before the wedding.

There are certain advantages to conducting bridal sessions: you have time to devote to producing a wide variety of images, without concern that you are keeping the bride from mingling with her guests; you can schedule the shoot to take advantage of good natural light; and there is more time to find great backdrops and play around with posing options and image concepts.

As an added perk, you can frame and display the bride's favorite shots at the reception.

EDGY OR TRADITIONAL?

I concentrate on coaxing a range of moods from the bride during bridal sessions. In the image below, I wanted a *Vogue* shot. The decor, pose, and expression create that vibe. The facing-page image is more traditional.

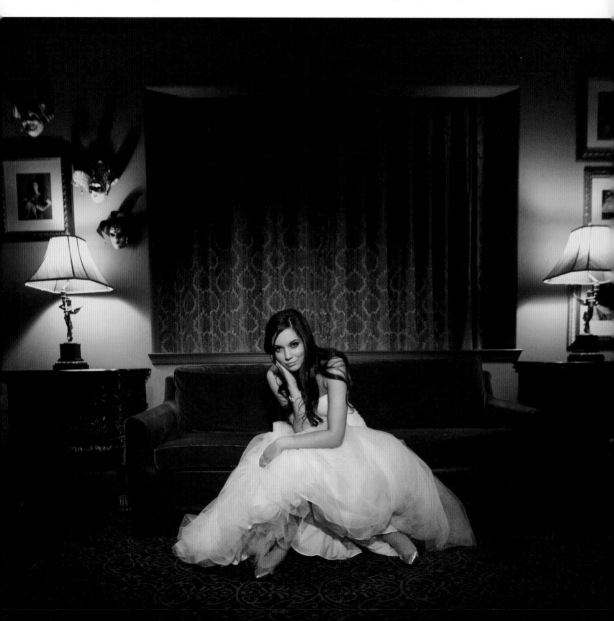

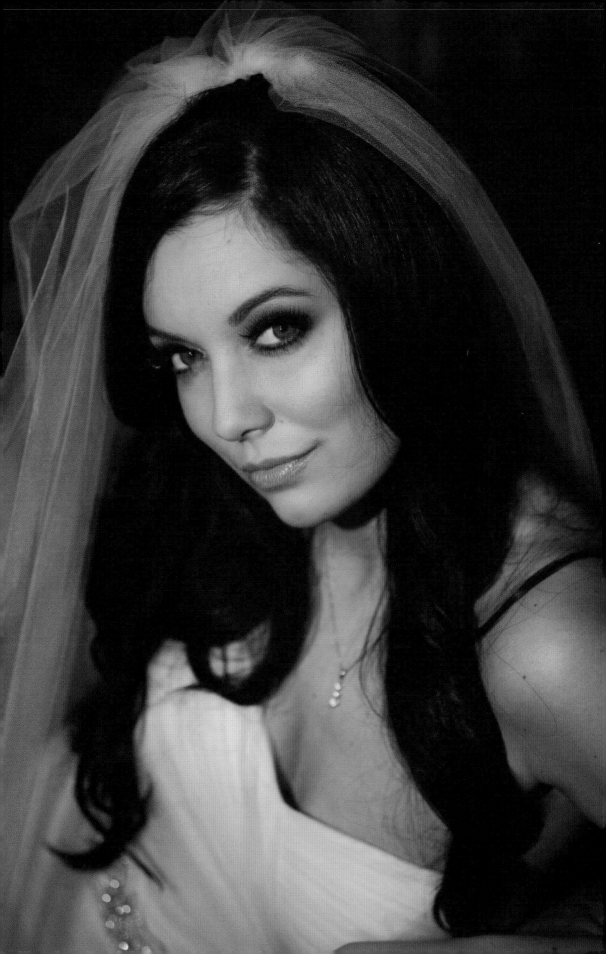

MORE OF A GOOD THING

These images were made during the session showcased in section 33.

My goal was to create magazine-style looks—clean, uncluttered, and dramatic—showing a variety of expressions, from sweet to seductive.

TIMELINE

My typical bridal session takes 1 to 1.5 hours. I try to shoot in as many locations as possible and strive to capture a wide range of looks so that the bride has a variety of looks to choose from when she selects her images.

AN OVERVIEW

The image on the facing page was made in a hotel room. The bride reclined on the bed and I shot from above. The linens and her gown create an all-white backdrop that puts the focus beautifully on the bride's eyes and soft expression. The result is a simple but elegant and timeless portrait.

USE WHAT YOU'VE GOT

As a photographer, you've got to learn to make the most of any opportunity that presents itself. The images below were shot in a parking garage. The space was dark; the only light coming into the area was from the garage door. I positioned the bride facing the opening and allowed the natural light to fall over her. The utilitarian—and unappealing—area behind her went black.

THE SETUP

Below is another image of the couple shown in section 32. This shot was also made at the San Antonio River Walk.

Specs

Canon EOS 1DX • 70–200mm f/2.8 lens at 88mm • f/2.8, 1/160 second, ISO 1000

My camera and I were actually positioned across the river from the couple, so I used a long lens (70–200mm) to zoom in for this view, which included their reflection in the water.

LIGHTING

My assistant used an off-camera flash, attached to a monopod, high above the couple and pointed down at them to get

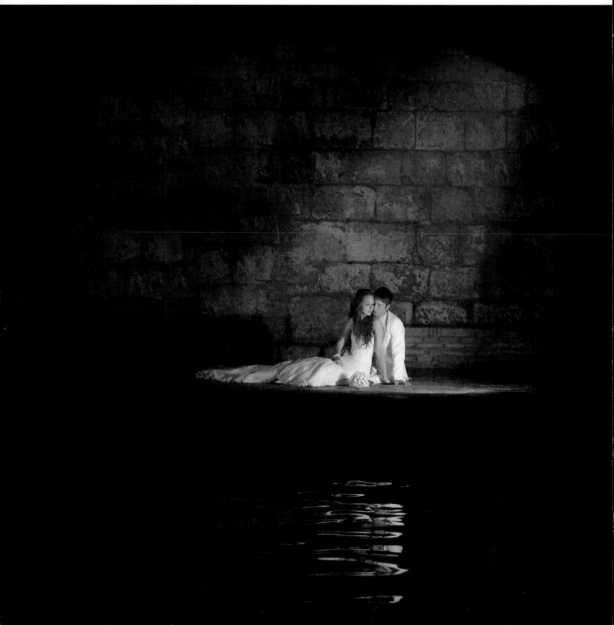

the lighting pattern you see here. We got a little reflection in the water that allows us to see some detail, and this keeps it from looking like a black hole. The light also nicely illuminated the rustic wall behind the couple.

THE POSE

I like the romantic feeling in this pose. The line of the dress leads to the faces, and we have a clear view of each subject. He is nuzzled in close to her, showing their emotional connection.

POSTPRODUCTION

I darkened the edges of the image in postproduction to keep the viewer's attention in the center of the frame.

SITTING TOGETHER

In wedding portraits of the couple, standing poses tend to be more common. As these images demonstrate, however, there is a certain relaxed charm that comes from letting the couple sit down and snuggle up close. The intimacy of their connection seems to shine through.

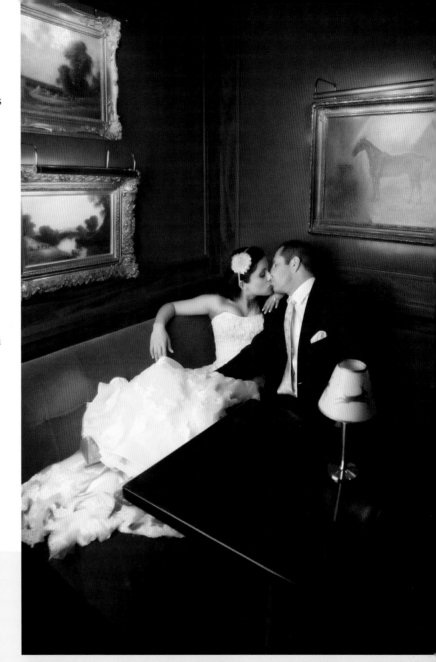

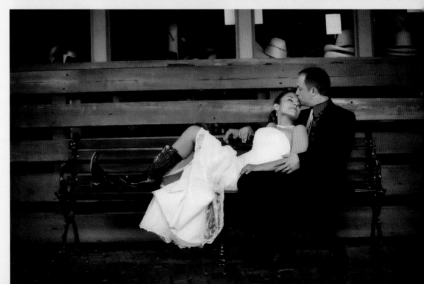

STAIRWAY SHOT

The image on the facing page was shot after the wedding, at the reception venue. It is common to photograph a bride coming down the stairs. In this image, I took a different approach.

I was drawn to the candle-like chandelier (shown more fully in the variations below) and thought it would be a great compositional component in an image of the couple. I positioned the bride and groom on the stairwell in a place where the chandelier would frame their faces and lead the viewer to the focal point of the image.

The diagonal line of the stairway's railing also directs the eye and helps create contrast in the image. Compositionally speaking, the brightest tones in the image will draw the eye; the groom's shirt and the railing pull the gaze to the couple.

DEPTH AND DIMENSION

There is a little light falling on the wall behind the couple, so they separate nicely from the background. Also, the shallow depth of field on the portion of the light fixture that is closest to the camera creates the feeling that we are peering through layers of lights to view the bride and groom. This establishes the impression of depth and dimension in the scene.

THE LIGHTING

I used a video light, placed at roughly the 7:00 position, to supplement the ambient light and illuminate the couple's faces.

ALTERNATE ARRANGEMENTS

In the two images on the left, the subjects are posed in the same area in which the main image was captured. I love this location. I like the way the shape of the architecture contains the subjects and its lines lead the viewers directly to the subjects. These images are graphic, contemporary, and dynamic—and they help to create a sense of place and document the unique location at which the reception was held.

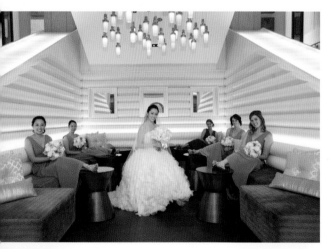

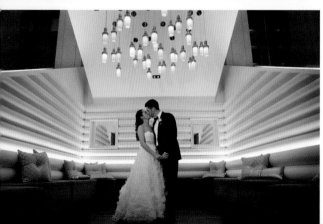

Specs
Canon EOS 1DX • 24–70mm f/2.8 lens at 70mm • f/3.2, 1/800 second, ISO 3200

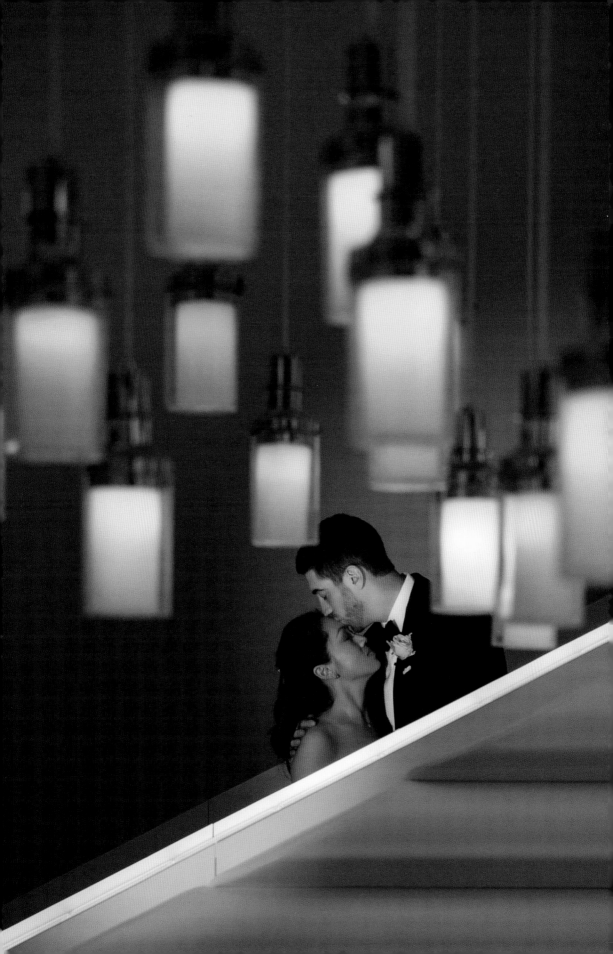

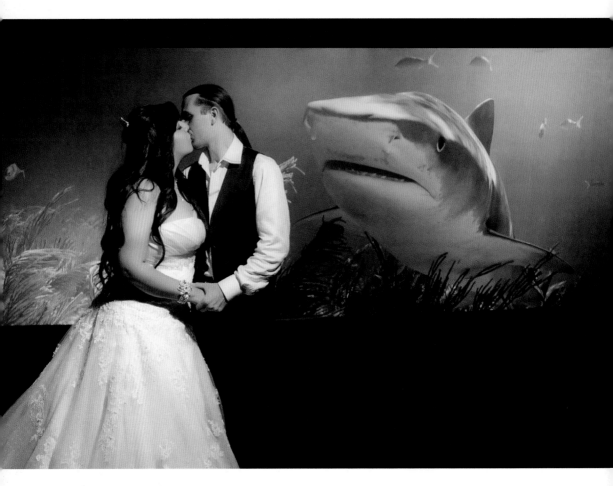

Tension and a bit of humor are both characteristics that can strengthen your images. Scenes like the one above and those on the facing page take a moment to interpret but then reward viewers with a smile. That can make them big winners.

LOCATION

The image above was shot at the National Aquarium in Baltimore, MD. The location was a favorite hangout for the couple, so it was meaningful for them to have their wedding portraits made there.

The couple is posed in front of a mural, but most viewers assume that it is a live shark. The shark adds a sense of tension and a bit of humor to the image; both characteristics can help to strengthen your images.

GOOFING AROUND

Every once in a while, you find yourself photographing a wedding with fun, unexpected elements. I've shot a wedding where the bridesmaids donned moustaches for the reception. In another, the guests were blasted with silly string.

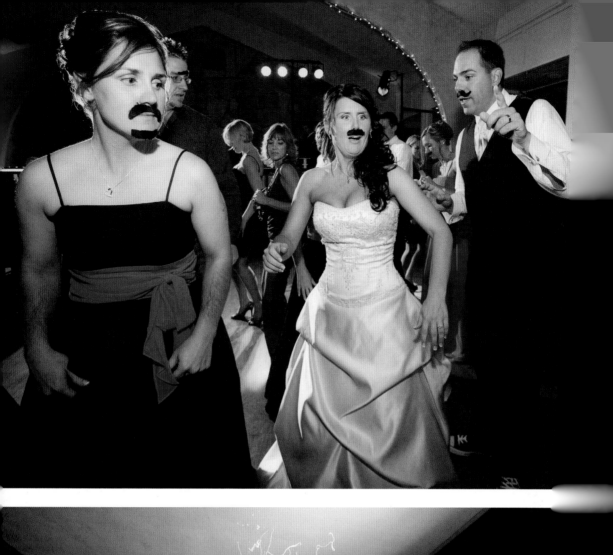
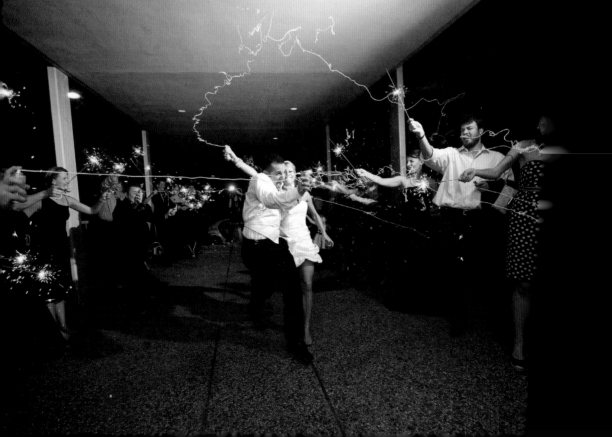

16TH CENTURY ENGLAND

This couple went all out when designing their Renaissance-themed wedding. They bussed their guests to the Scarborough Fair in Waxahachie, TX. Everyone was attired in period clothing (except for yours truly; apparently, I missed the memo). They even dined as they would have in the Renaissance, with a main course that included a big turkey leg.

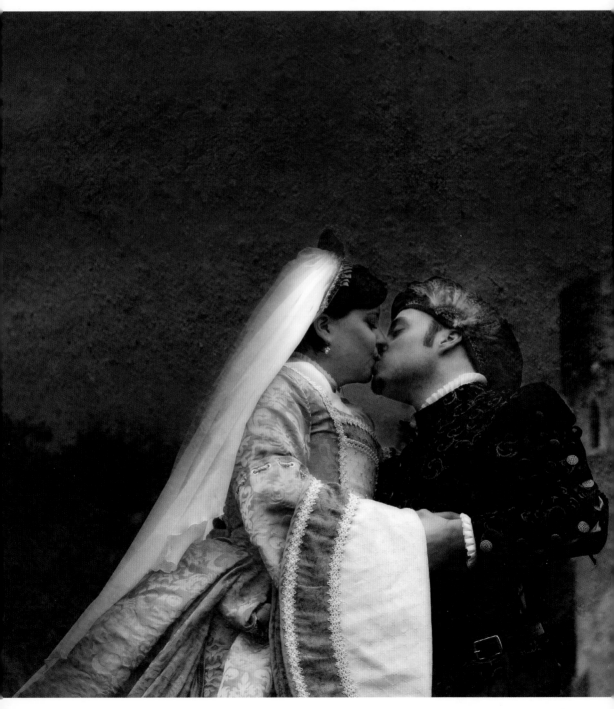

THE CONCEPT

The fairgrounds featured a real castle. Therefore, it was a no-brainer that some shots of the couple in front of the castle were in order. The costumes, an era-appropriate pose, and the castle are all harmonious. I shot from a low angle to emphasize the grandeur of the castle.

This was one of the couple's favorite images from the day. It is one of my personal favorite wedding images because it is so different.

LIGHTING

This image was made with all natural light. The day was overcast, so the light was diffuse and flattering.

POSTPRODUCTION

I added the texture over the sky in Photoshop. I felt that it gave the image a more old-timey feel.

> **" I shot from a low angle to emphasize the grandeur of the castle. "**

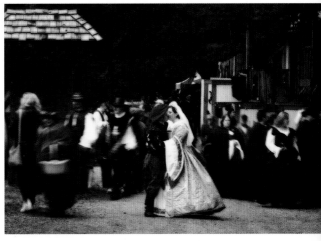

Specs
Canon EOS 5D MK III • 70–200mm f/2.8 lens at 80mm • f/3.5, 1/200 second, ISO 1250

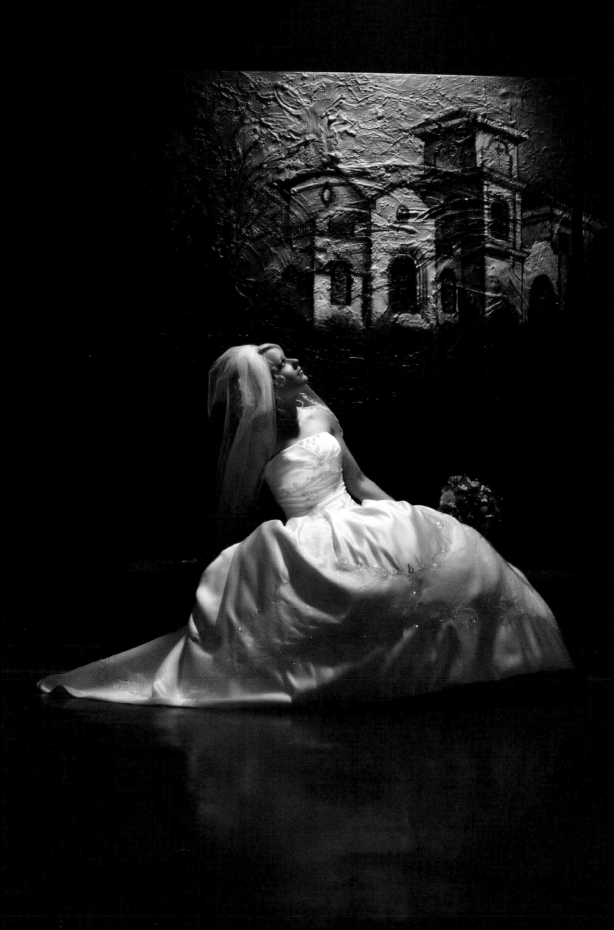

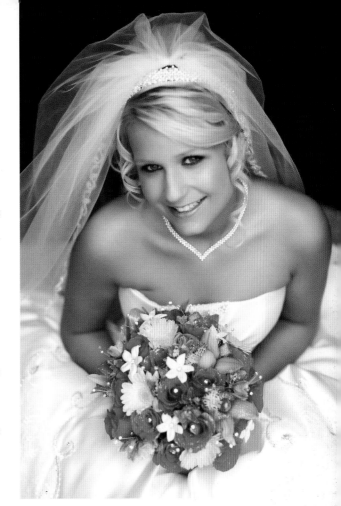

LIMITATIONS

Some venues lack sweeping stairways, giant chandeliers, and elegant spaces. When you're shooting in a place that's not so showy, you'll need to get creative to capture a range of dynamic portraits.

WORKING THE SCENE

For the featured image, I positioned the bride in front of a mural and prompted her to tip her head up toward the ceiling light. I opened a door behind me to allow light to fall on her. The majority of the room was still dark, and the result is dramatic.

For the top-right image, I shot from overhead and cropped close. The eye travels between the bride's smiling expression and her vibrant bouquet.

The final image was an action shot. The full-length capture allows for a full view of the dress. I love her expression; I enjoy capturing natural moments.

❝ The majority of the room was still dark, and the result is dramatic. ❞

Specs

Canon EOS 5D MK III • 70–200mm f/2.8 lens at 80mm • f/2.8, 1/60 second, ISO 4000

A CRITICAL IMAGE

During every wedding I shoot, I like to capture an image of the bride zipping up her dress. Though she may not be alone in the room, I typically ensure that she is the only subject in the frame. It gives the portrait a contemplative mood.

When capturing these images, I like to shoot with a wide angle lens so that the

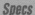

Specs

Canon EOS 5D MK II • 16–35mm f/2.8 lens at 16mm • f/2.8, 1/125 second, ISO 2000

environment plays an important role in the image. I often strive to include the mirror and any other interesting architectural or decor elements as well. In this way, I create a sense of place that helps to tell the story of the day.

THE APPROACH

I shot from a low angle to create an interesting perspective. Note that the eye travels between the subject and her reflection. Her reflection is framed by the bright window reflections and also, of course, by the ornate mirror frame.

The image was made with all ambient light. I used a slower shutter speed to capture all the soft, warm light.

THE DRESS ALONE

Before the bride slips into her gown, it's nice to capture an image of the dress hanging in a beautiful setting (or draped across a lovely bed).

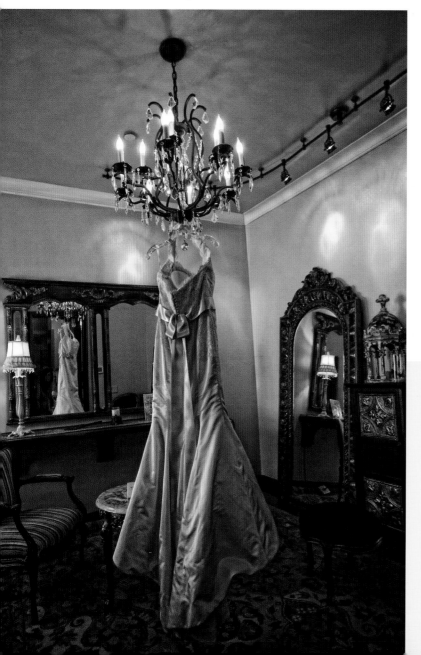

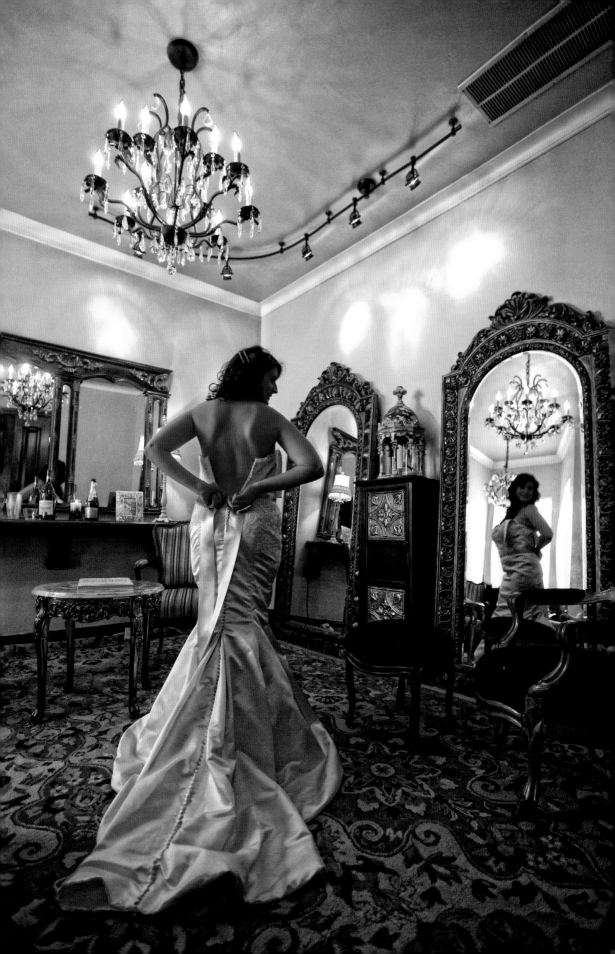

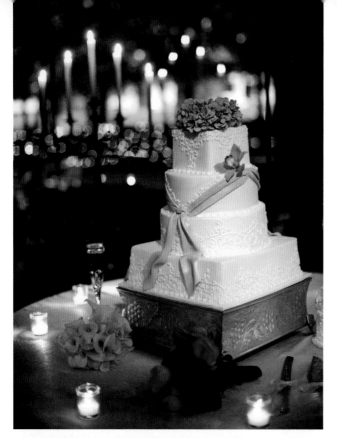

IT'S IN THE DETAILS

The wedding cake is iconic, and getting a great shot of it is important to the bride and groom.

ALBUM DESIGN

Cake images, and other detail shots, are an important element in the wedding album and can make great leading images when introducing the reception portion of the album.

CREATING IMPACT

There's no denying that the towering, well-appointed cake shown in the featured image raised a few eyebrows. It was elegant and carefully presented on a table beneath an eye-catching chandelier. The lighting in the room was warm and subdued—factors that helped to create a romantic impression.

I composed this image to take advantage of the symmetry in the scene. I love the triangular shape that the chandelier and wall sconces create. They frame the cake and lock the viewer's gaze on the centerpiece.

I needed more light for a proper exposure and to retain detail in the scene, so my assistant held a monopod-mounted light at camera right.

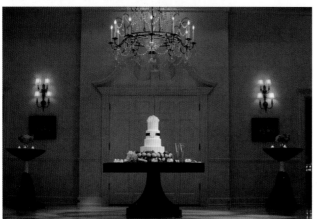

Specs

Canon EOS 5D MK III • 70–200mm f/2.8 lens at 70mm
• f/3.5, 1/200 second, ISO 1250

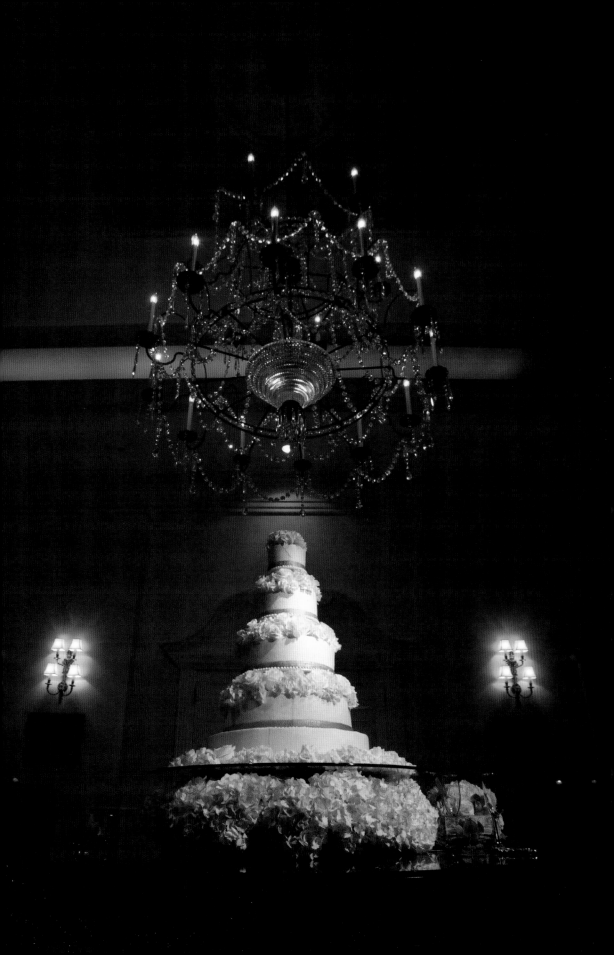

A WOW IMAGE

In these images, the bride and groom are diminutive in the frame. Why is that? It's because, in each case, they are not the point of the image. My intent for this type of image is to showcase the beautiful structure of the magnificent churches.

To capture this kind of image, I kneel down on the ground and allow the camera to rest vertically on the floor. My goal is to capture a compelling view of the aisle the bride and groom have just walked down, the pews on either side and, of course, the grandeur of the ceiling. The ceremonial site the couple chooses holds special meaning for them. Accordingly, it never hurts to devote a few frames to the things that make it special.

AMBIENT LIGHT

I never use flash during the ceremony. These images were made using only the available light.

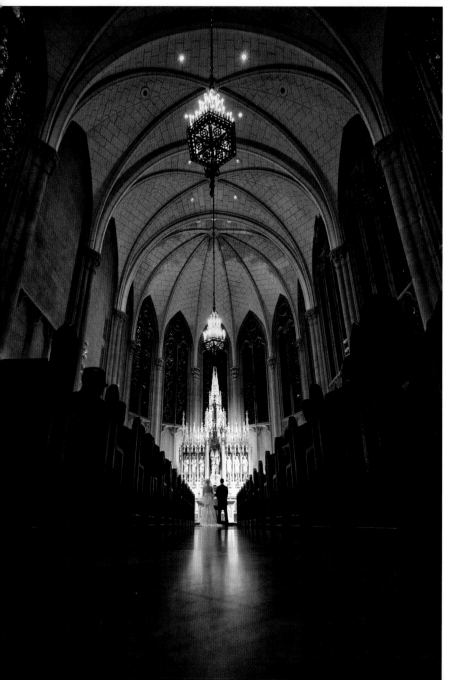

66 I kneel down on the ground and allow the camera to rest vertically on the floor.99

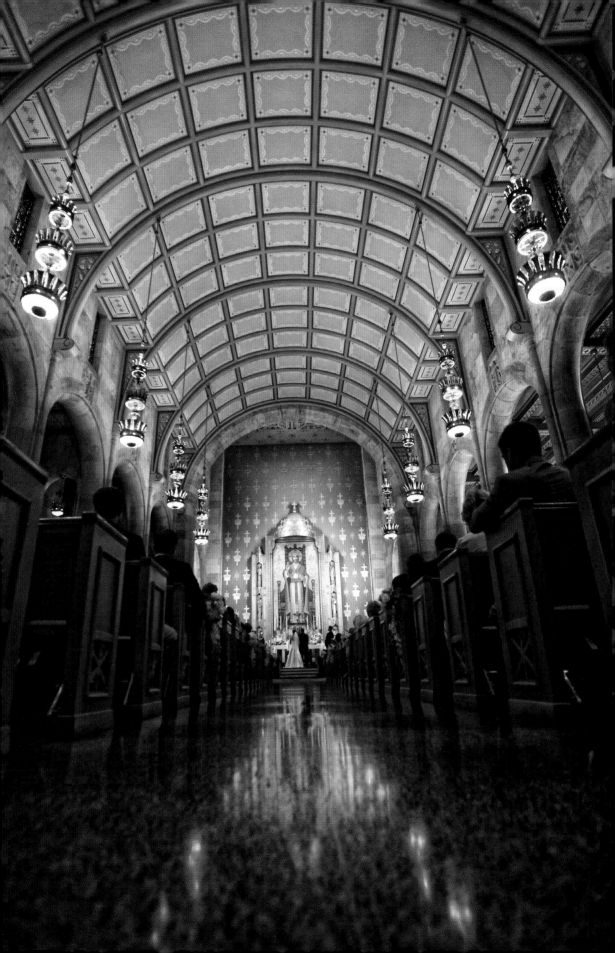

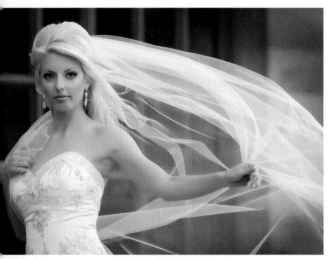

TWO LOOKS, ONE LOCALE

The main image and the shot of the bride reclining were both taken on the brick stairway, but the posing variations and mood in each is distinctively different. Try to maximize your image potential by varying the image format and your camera angle and, of course, trying alternate poses and coaxing varied expressions.

MOVEMENT

As I mentioned earlier, I love a wind-caught veil. This photogenic bride struck a cool, aloof expression that's simultaneously soft and strong.

In the image below, the bride appears lost in her own world, completely unaware of the fact that she is being photographed. Where is she going? What is on her mind? The image has a mysterious quality that engages viewers and suggests a storyline.

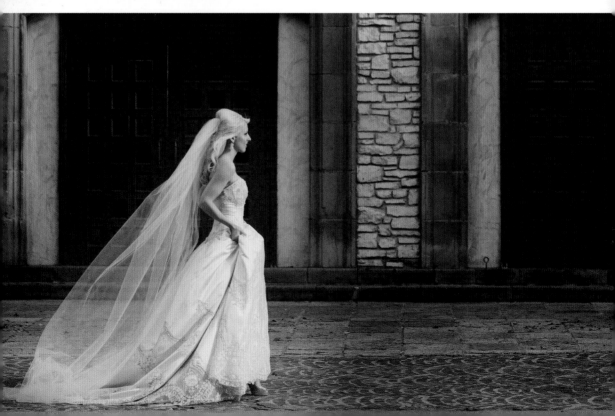

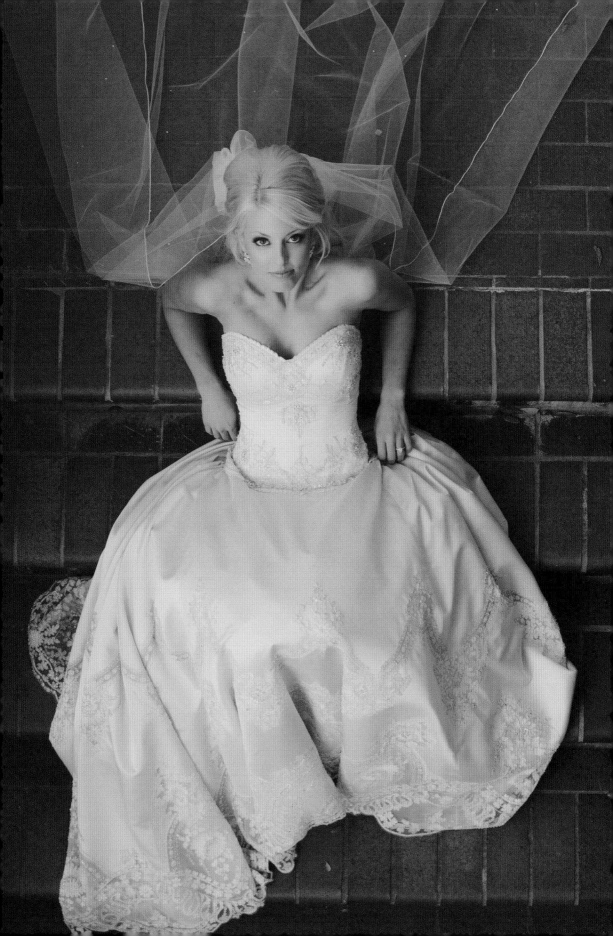

I DO

As seen in the image on the facing page, brides often write cute messages on the bottom of their shoes. This particular bride and her bridesmaids were getting ready in a small room. There was nowhere to get a great photo of the shoes, so I found this wrought-iron door to a patio and decided it would be a good place to stage the shot.

I hooked the heels of the shoes over a horizontal door element that fell roughly one-third of the way from the top of the image frame to help ensure a compelling composition.

LIGHTING

The shoes were backlit by natural light coming through the door. The soft lighting on the metal and the shoes creates a romantic feeling. The greens in the foliage blur nicely, creating a contrasting backdrop that creates separation and allows the shoes to pop. Due to the wide aperture, there is beautiful bokeh in the highlights where the light shone through the trees.

GEOMETRY

The repeating elements in the door frame create a sense of movement in the image. Though this is a still life, it does not seem static. The circular elements and horizontal lines frame the horizontally centered shoes, and the words "I do" fall squarely between two lines. These compositional elements quickly establish the fact that "I do" is the point of focus in this image.

Specs

Canon EOS 1D MK IV • 50mm f/1.2 lens • f/3.2, 1/640 second, ISO 1000

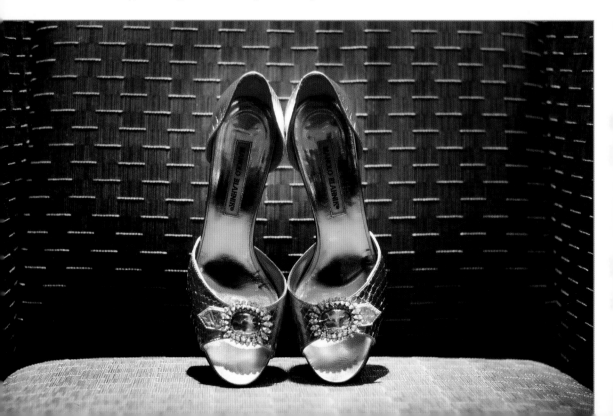

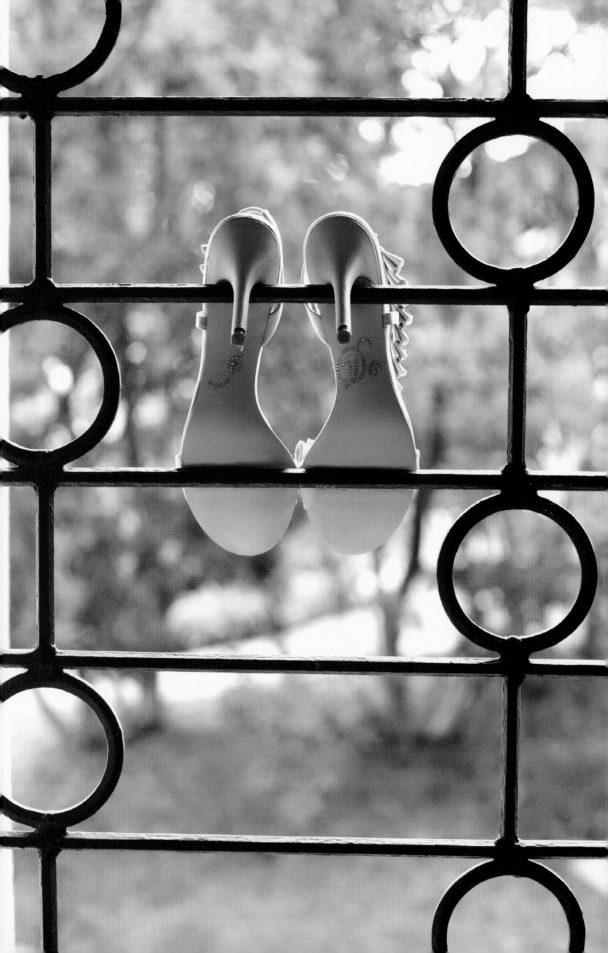

Read Her Lips

I love to capture images of the bride putting on her makeup or jewelry. In this case (left), I featured her beautiful red lips and gorgeous engagement ring as she fastened her earring.

HIGHLIGHT AND SHADOW
Skin tones and shadows comprise most of the frame, drawing your eye straight to the bride's slightly parted, shapely red lips.

GETTING THE SHOT
Using a long lens allowed me to capture the image from farther away from the bride.

MIRRORS
Mirrors naturally factor into the early part of the day, so they help set the scene and create a nice compositional element.

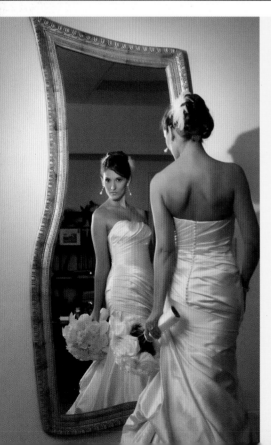

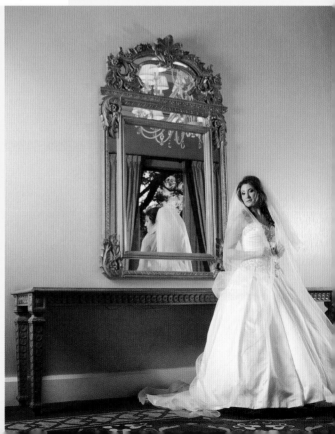

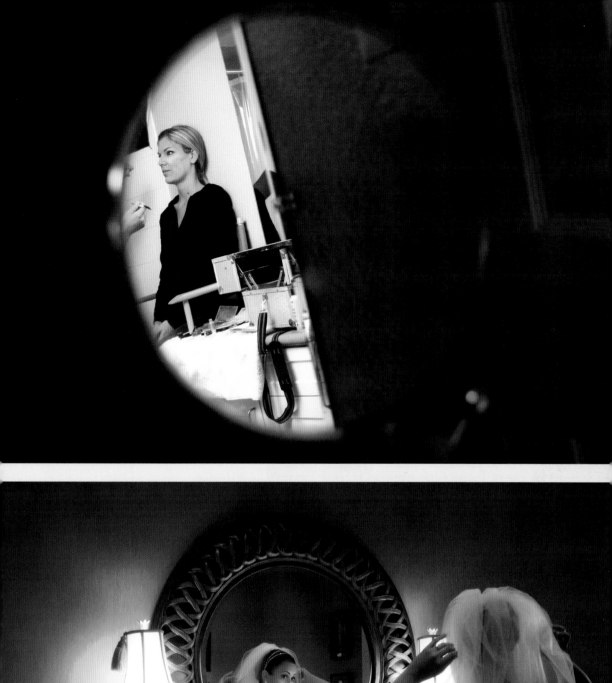
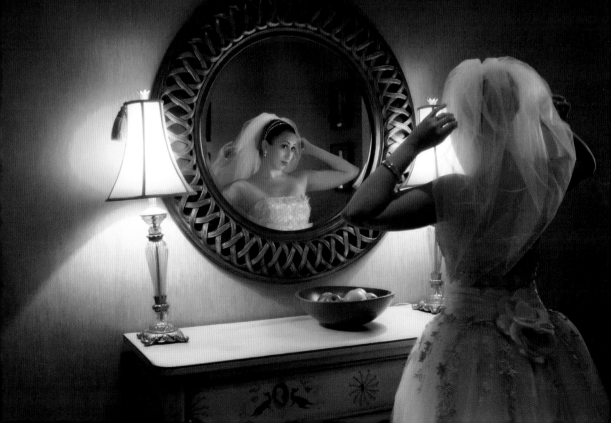

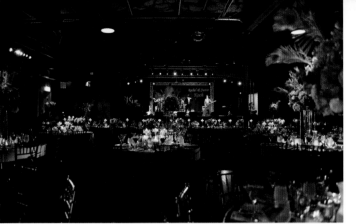

THE FRUITS OF THEIR LABOR

The bride and groom painstakingly spend months or years planning every detail of their wedding. Yet, on the wedding day itself, they are usually so caught up in the goings-on that they can't devote much time to appreciating the fruits of their labor.

TIMING IS EVERYTHING

When it comes to the details of the reception, there is yet another complicating factor: by the time the bride and groom enter the room where the reception is being held, the guests are already in place and things have been moved and dirtied.

PLAN AHEAD

Therefore, it is a good idea to make arrangements (with the wedding planner or venue) to get into the reception room and take images before any guests set foot in the space. You can also ask the staff to clear the room for just a few minutes while you capture an overview of the room in all of its splendor.

> " The bride and groom painstakingly spend months or years planning every detail of their wedding. "

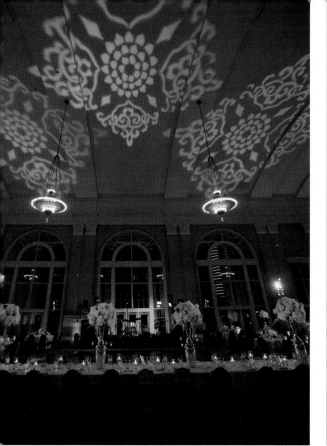
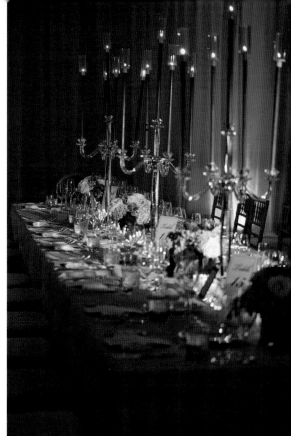
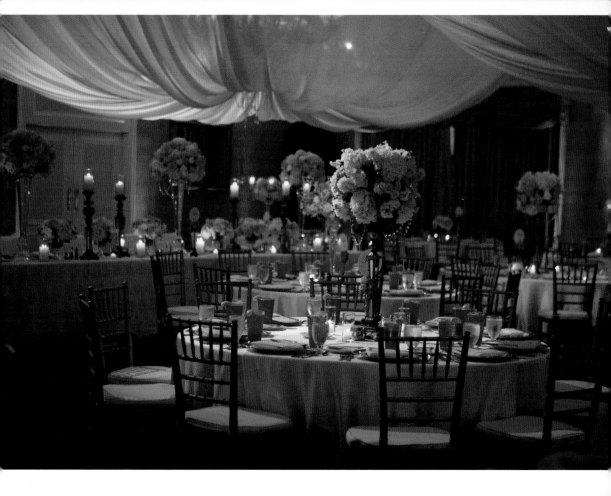

A DIFFERENT APPROACH

I like to photograph the rings differently than many other photographers do. As shown here, I often place the rings on an invitation or program—something with the couple's names on it, and possibly their

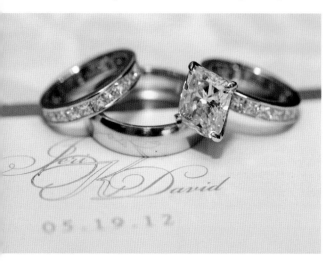

wedding date—or, in some cases, will position them on a bible. I like the graphic element and personalization that incorporating text adds to the image—and my clients love it too.

OFF-CAMERA FLASH

Flash adds a certain sparkle, shine, and detail to ring shots that ambient light just can't produce.

I often work with a speedlight, set to 1/4 power, positioned at camera left, very close to the rings. Adding directional light from the side allows me to better show detail in the jewelry.

I mount a second speedlight on my camera and use it to trigger the off-camera speedlight and add a touch of fill light in the images.

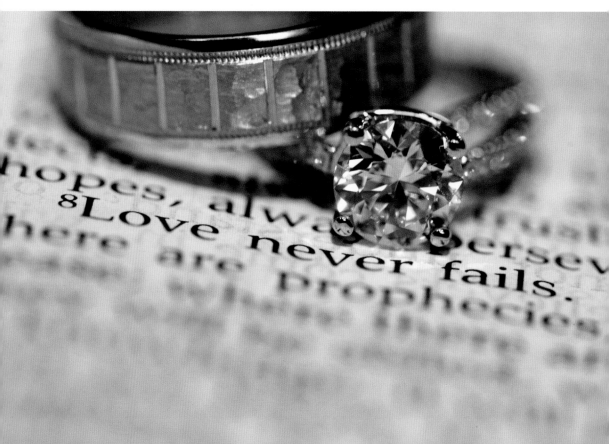

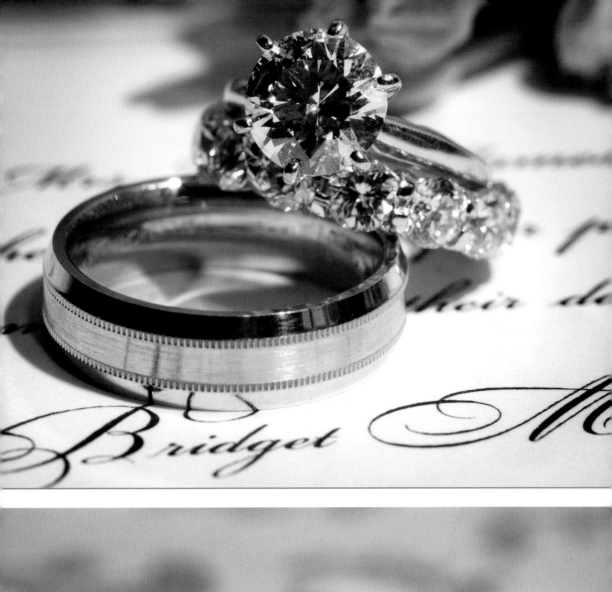

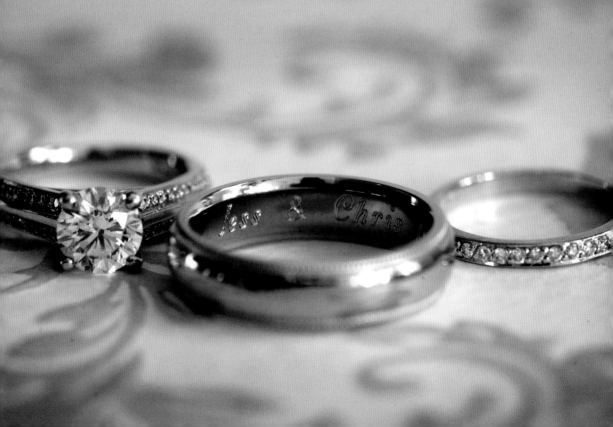

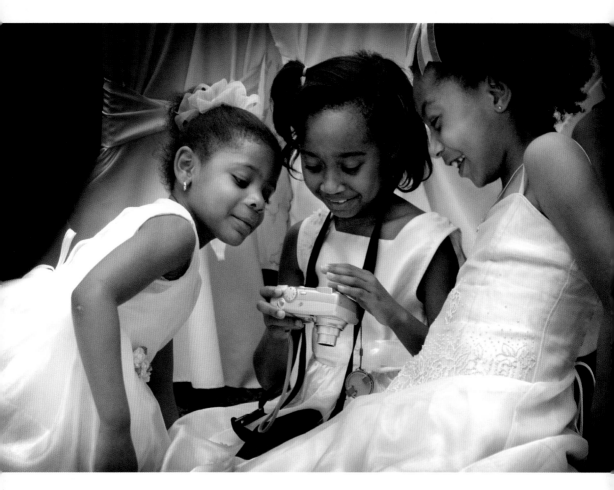

TELLING THE STORY

In between the "must capture" moments of the reception, there is plenty of time to get images of the guests interacting. Candids help the bride and groom to "fill in" their memories with moments that they were not able to witness. Keep your eyes open for opportunities to capture emotion and document special moments as they unfold.

A BUDDING PHOTOGRAPHER

The girls in the image above were sitting at the side of the dance floor during the couple's first dance. One of the kids had been photographing the dance, and the trio took a moment to check out the results.

LIGHTING

There were flashes set up in the corners of the room to ensure a proper exposure for the dance images.

BLACK & WHITE

As seen in all these images, converting to black & white or sepia often helps bring the emotion of the moment to the forefront.

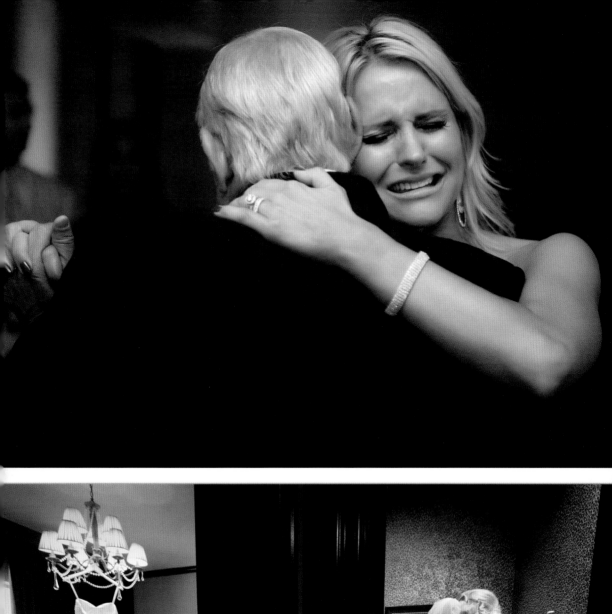

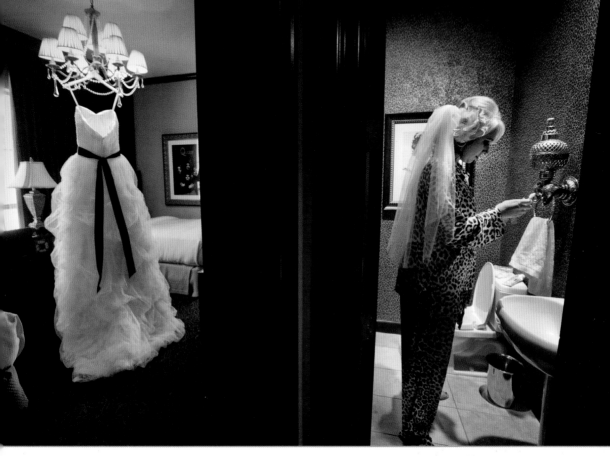

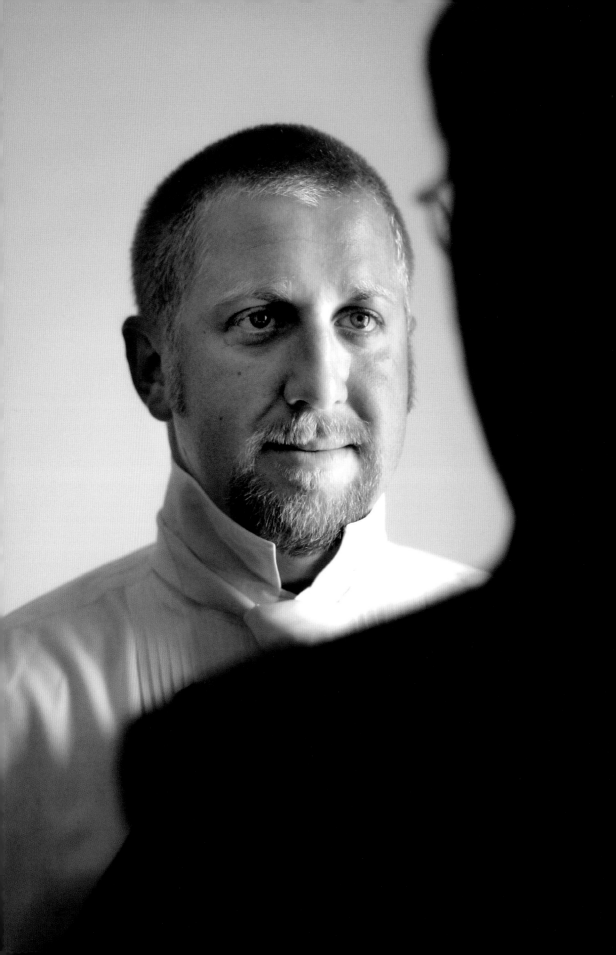

While the beautiful bride is often the focus of the wedding (and wedding photography), it's important to remember that weddings are big events for the men, too. Be sure to devote some time to capturing meaningful images that reflect his experience of the day.

PREPARATIONS

The preparation phase is a time when the bride especially tends to get the lion's share of the attention—so it's nice when you are able to create some preparation shots of the groom, too. I think the image on the facing page is quite a special example of this. Here, we have the groom (who is well lit) receiving help with his tie from his dad (who is in silhouette). Of course, this moment is unique in that the groom does not typically get any help with his preparations. This is a bonding moment between father and son.

LIGHTING

There was a window behind the groom and to the right. I shot from behind the dad; he is in silhouette and the only detail that viewers can clearly make out on him is the frame of his eyeglasses. This makes for a powerful image.

Specs
Canon EOS 5D MK II • 50mm f/1.4 lens • f/1.4, 1/350 second, ISO 200

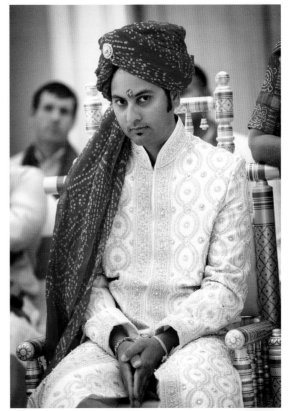

AT FIRST GLANCE

Many people have thought, at first glance, that this image (facing page) was taken in a mirror. That is not the case. There are two different flower girls here and there are two bridesmaids who are helping them prepare for their important role in the ceremony. When I saw this scene unfolding, I was able to capture the image from the sidelines with my telephoto lens.

I have received numerous awards for this image.

WATCH THE KIDS

Children have varied reactions to the new clothes, places, people, and environments that weddings entail—and they often wear these feelings on their sleeves. So keep an eye open for fascination, playfulness, or surprise (and maybe even frustration or boredom)!

LIGHTING

The subjects were illuminated by light coming from a small window at camera left. I used a slow shutter speed to take advantage of the ambient lighting, so there was no need for flash or reflectors.

POSTPRODUCTION

This image has a dramatic quality due to the strong contrast and serious expressions. Presenting it in black & white, with a soft sepia tone, lets viewers home in quickly on the actions and expressions that made this moment special.

> " This image has a dramatic quality due to the strong contrast and serious expressions. "

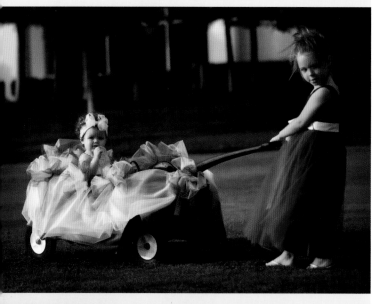

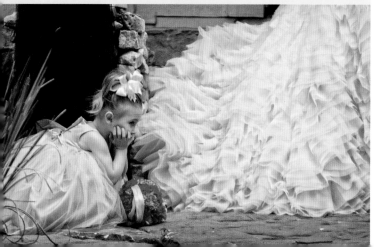

Specs

Canon EOS 5D • 70-200mm f/2.8 lens at 70mm
• f/2.8, 1/60 second, ISO 1250

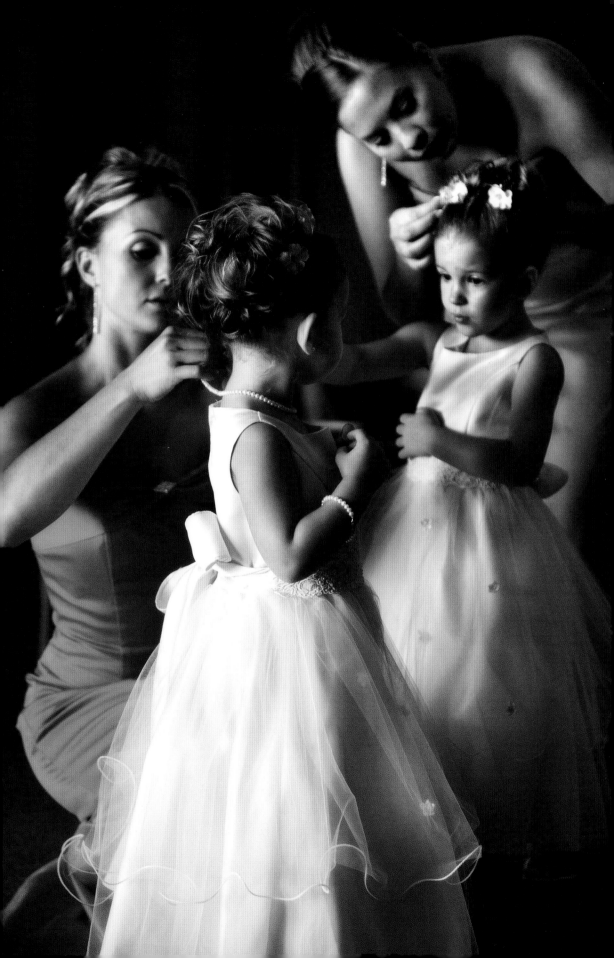

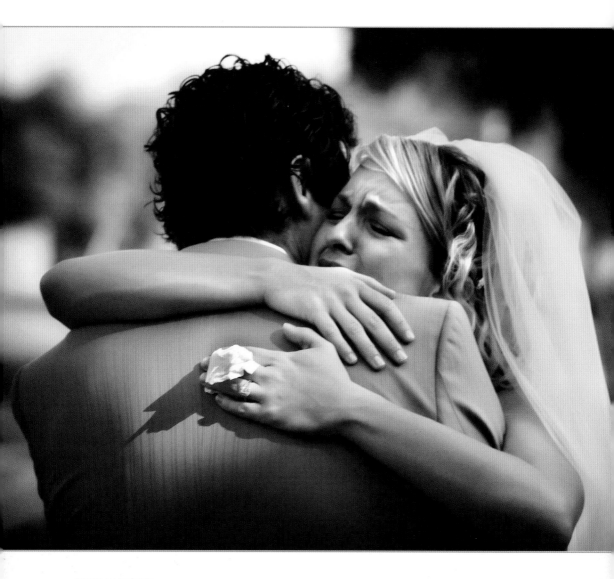

HIGH EMOTION

It's our practice to orchestrate a private "first look" event for the bride and groom. We find a quiet, out-of-the-way place for them to see one another for the first time, alone, before the ceremony. We typically pose the groom with his back toward the direction from which the bride will be walking up to him. When she reaches him, she taps him on the shoulder, and he then turns to face her.

Specs
Canon EOS 5D • 70–200mm f/2.8 lens at 155mm • f/5.6, 1/250 second, ISO 200

When the couple comes face to face, the emotion is always strong. In this case (facing page), the bride broke down as soon as the groom turned around, and he became emotional too. We stood off in the distance and captured the shots unobtrusively—we feel it's important to give the couple as much privacy as possible while documenting the event. This is an intimate moment.

posed to waiting until the ceremony to see one another. The fact of the matter is, doing the first look allows for a private, memorable moment *and* gets the couple together so that they can have their wedding images made and "get them out of the way" so that they can spend more time with their guests later in the day.

OUT WITH THE OLD

More and more couples are opting to take advantage of the first look option, as op-

A LONG TIME COMING

Take advantage of unique opportunities to document the anticipation the couple feels.

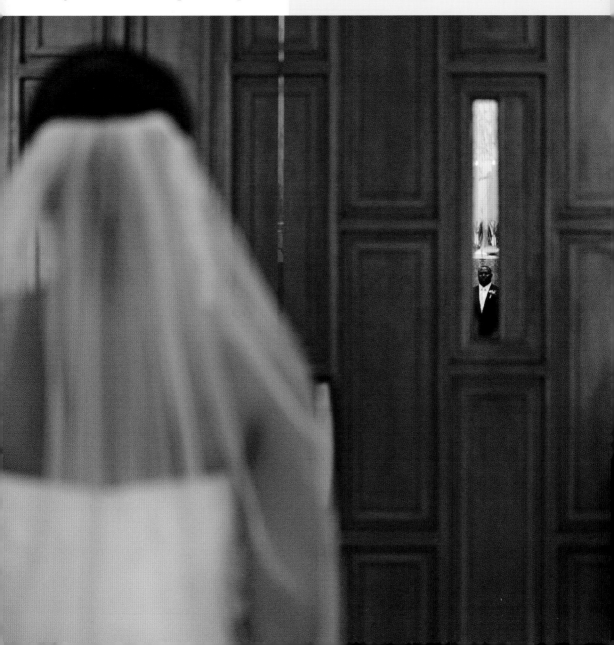

LOST IN THE MOMENT

I just love this image of the little girl helping the bride put her shoe on (facing page). The bride's love for the girl is apparent in her eyes as she looks down patiently. The image documents a tender, memorable moment the two of them shared on this important day. Happily, I was able to witness and capture this moment as it happened. It was purely candid.

LIGHTING

This facing-page image was made using only natural light. After all, I did not want to intrude on the interaction. The light levels were fairly low in the hotel room, so I used a wide aperture, a higher ISO setting, and a slow shutter speed to get the shot.

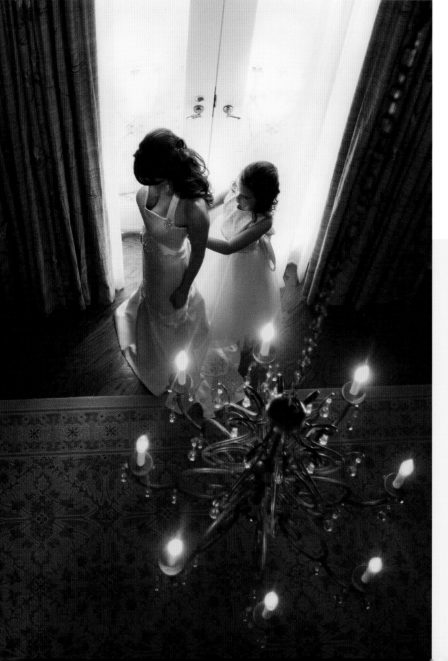

Specs

Canon EOS 5D MK III
• 70–200mm f/2.8 lens at 70mm • f/2.8, 1/125 second, ISO 1600

A FRESH PERSPECTIVE

I'm always looking for opportunities to get a different perspective on the scene. The image on the facing page was shot from quite a low camera height; the image to the left, conversely, was shot from a high angle. This allowed me to capture more of the space that set the scene for this sweet moment.

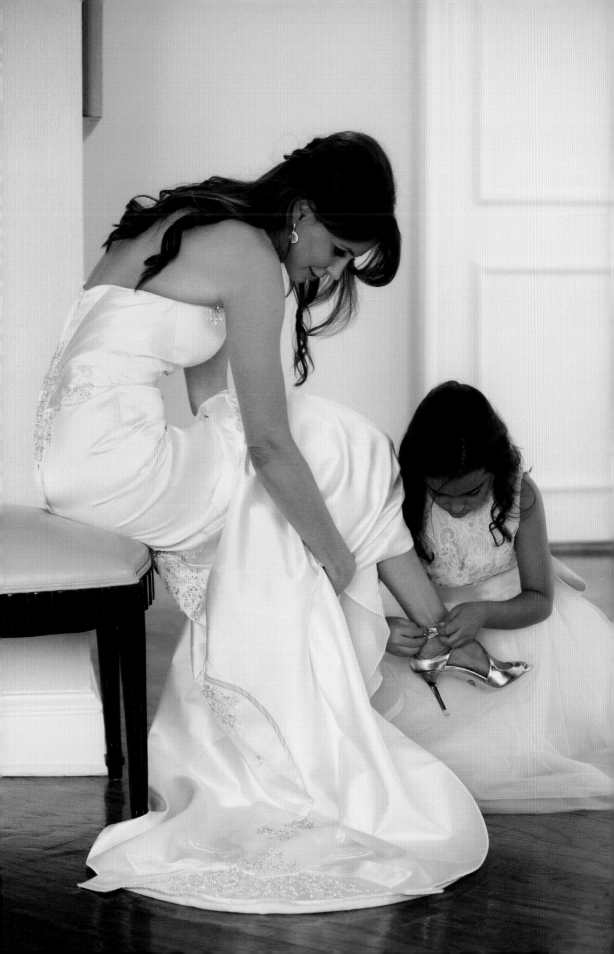

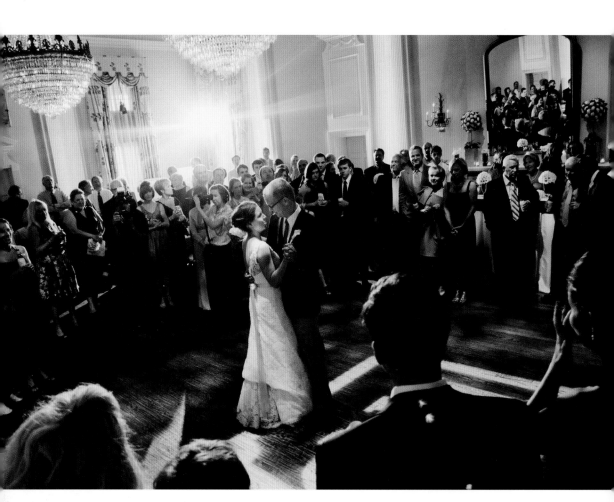

GROUP SHOTS

I believe that it is important to capture an image of the bride and groom in the midst of everyone who has gathered to celebrate their wedding day. It is a nice supplement to the more traditional images that the bride and groom will expect you to capture.

Specs
Canon EOS 5D MK II • 16–35mm f/2.8 lens at 17mm • f/4, 1/80 second, ISO 1600

For the image above, I wanted to get everyone in the shot and capture a pleasing perspective. So, I quickly climbed onto the stage where the band was performing—you don't want to stand there for long!—and got a couple of shots looking down onto the dance floor.

CREATING MOOD

You can see my off-camera flash in the background of this image, lighting the dark room. The starburst effect, combined with

the mirrors and chandeliers, helps to lend an elegant, Old Hollywood feeling to the photograph. The sepia tone was added in postproduction to enhance the vintage vibe.

DEPTH AND DIMENSION

This sweet sepia image features spectators in the foreground, the bride and groom in the middle ground, and guests filling the background. With visual interest discernible from the front to the back of the frame—and the mirror on the right of the frame showing even more of the assembled crowd—we get a real feeling for the space in which the reception was held.

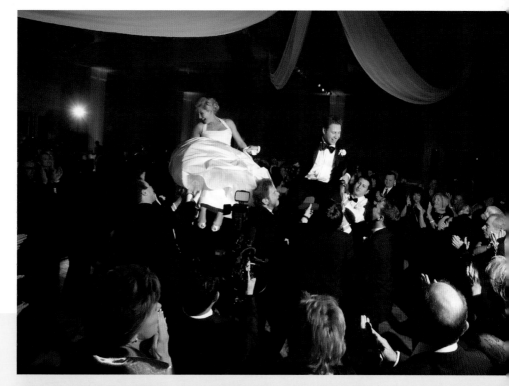

BIG EMOTIONS

By the time they're dancing at the receptions, months of planning are now behind them and there's nothing to do but enjoy the party! Watch for laughter and smiles as the couple cuts loose with their friends and family.

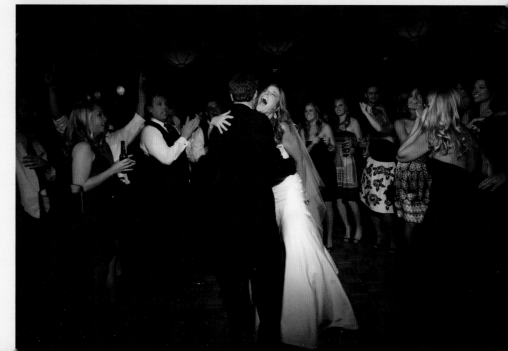

VIDAAI

In the Indian tradition, "Vidaai" is a post-wedding ceremony that takes place just before the Indian bride leaves her parents and associates to begin her life as a wife and a member of a new family. It is a time of intense emotion—a blend of happiness over what lies ahead and sadness over what is being left behind. Be sure that you will be in the right place at the right time to document this ritual.

THROUGH THE WINDOW

In this image (right), we have the bride's father, photographed through the open window of the car in which the bride is leaving the ceremony. The bride is seated near

66 It is a time of intense emotion – a blend of happiness over what lies ahead and sadness over what is being left behind. 99

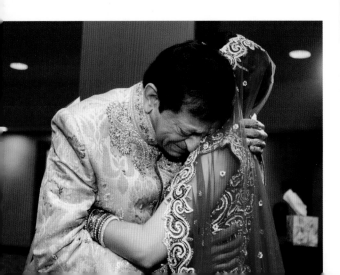

her dad and the two are holding hands. His face is full of expression, and though we cannot see the bride's expression, we are left to imagine that her face is filled with emotion too.

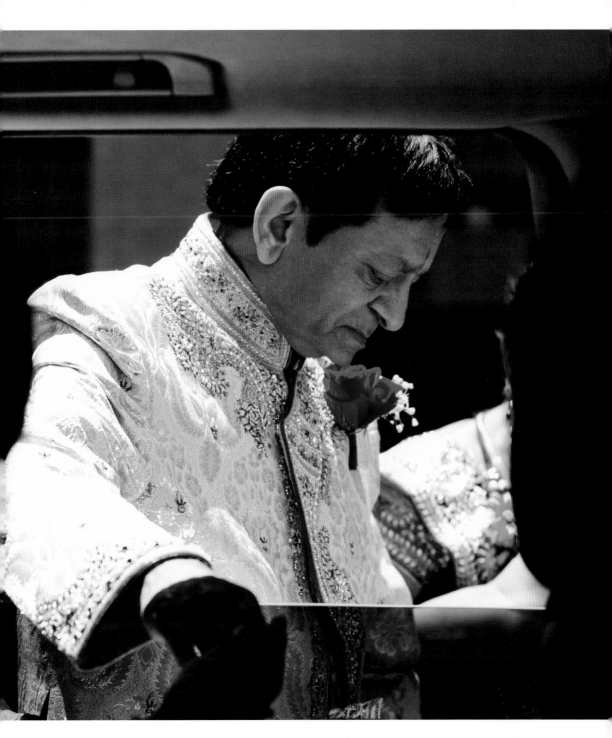

I tried to include details of the car to create a frame of reference for the action that is taking place in the photograph. There is no doubt that the story has been effectively conveyed.

Specs

Canon EOS 1D MK IV • 70–200mm f/2.8 lens at 70mm • f/3.5, 1/4000 second, ISO 800

WHAT MAKES IT UNIQUE?

Every couple is unique and each wedding has its own special flavor.

In this case (facing page image), the two flower girls and ring bearer were provided with some sweet—and humorous—signs to carry during the recessional. As you can imagine, it was a moment that absolutely stole all the attendees' hearts. It was impor-

Specs

Canon EOS 1DX • 70–200mm f/2.8 lens at 70mm • f/2.8, 1/50 second, ISO 4000

tant to capture the image to preserve the special memory.

The photograph was taken from a low angle to get a shot from near the kids' eye level. I like the emotion on the young subjects' faces. It takes the charm of the image to another level.

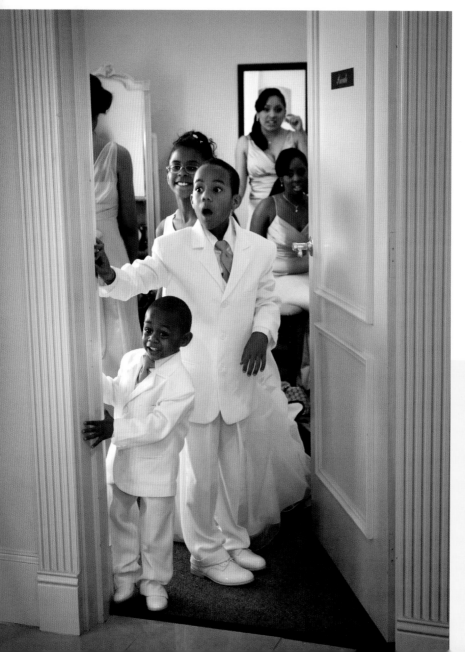

LIGHTING

As I mentioned earlier, I never use flash during the ceremony. I simply rely on the ambient lighting and choose exposure settings that ensure a proper exposure.

WHOA!

Planned moments aren't the only times when kids can steal the show at a wedding. The expressions on these young men's faces were too good to miss!

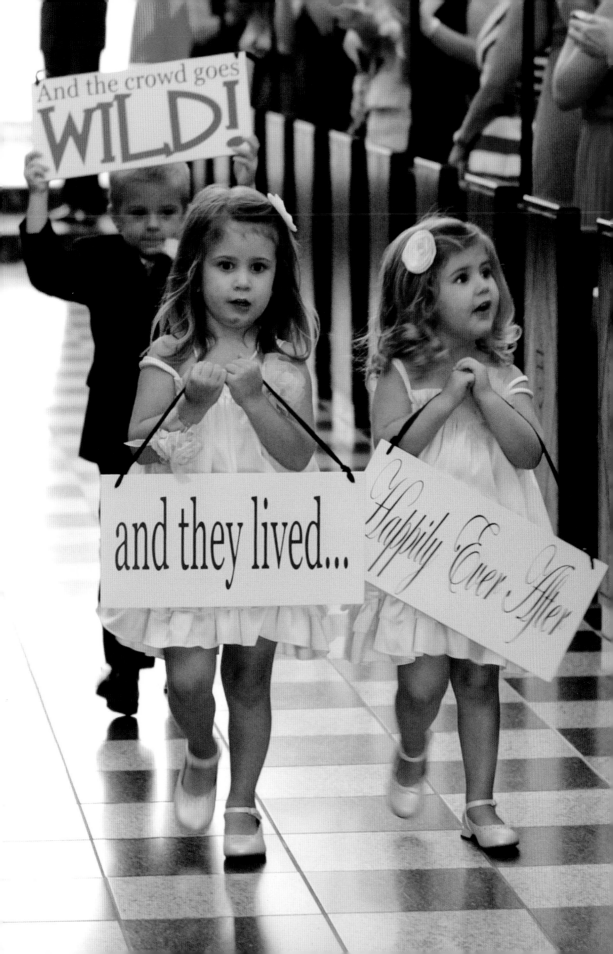

EXPRESSION IS EVERYTHING

Sometimes, the expression speaks volumes. This image (facing page) proves the point. The couple seems to be lost in one another. With their eyes closed, they are not communicating with the viewer. This fact helps to emphasize the suggestion that they are shutting the world out. This moment is all about them.

THE POSE

It's really great to have the opportunity to capture the bride and groom while they enjoy each other's company. I like to use a long lens so I can work unobtrusively and afford them some privacy.

In the featured image, the bride and groom were positioned under an overhang, so there was nice flattering, directional light on the bride's face.

Specs

Canon EOS 1DX • 70–200mm f/2.8 lens at 70mm • f/2.8, 1/3200 second, ISO 1000

BACKLIGHTING

The sun was behind the couple. As a result, there is a touch of flare in this image, which leads to subdued tones and creates a fashion feel, which is popular with wedding clients today.

THEIR OWN LITTLE WORLD

Wrapping the couple in the bride's veil momentarily isolated the couple from the rest of the world. The dreamy, soft lighting and the couple's expressions reinforce this sense that the world is just these two.

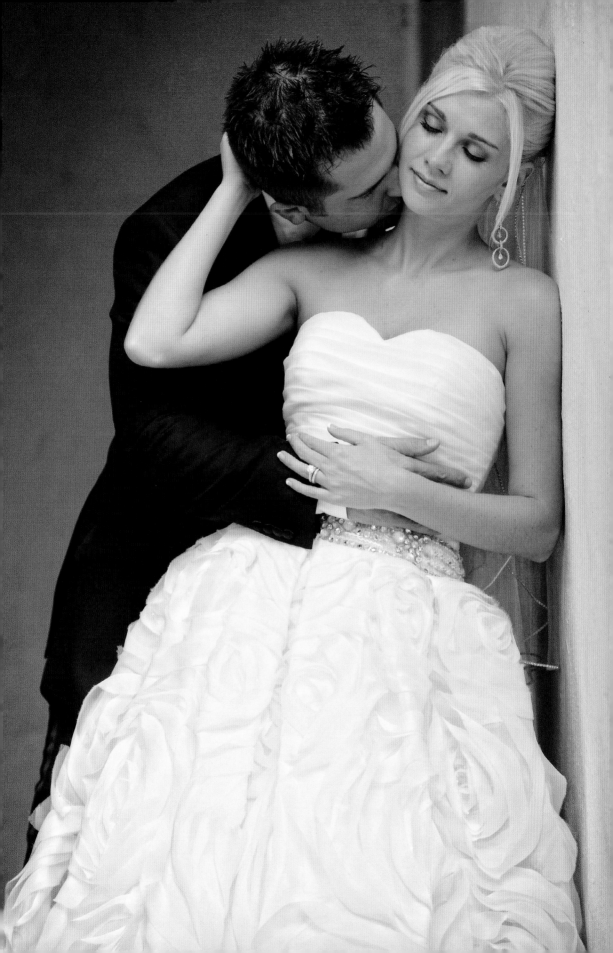

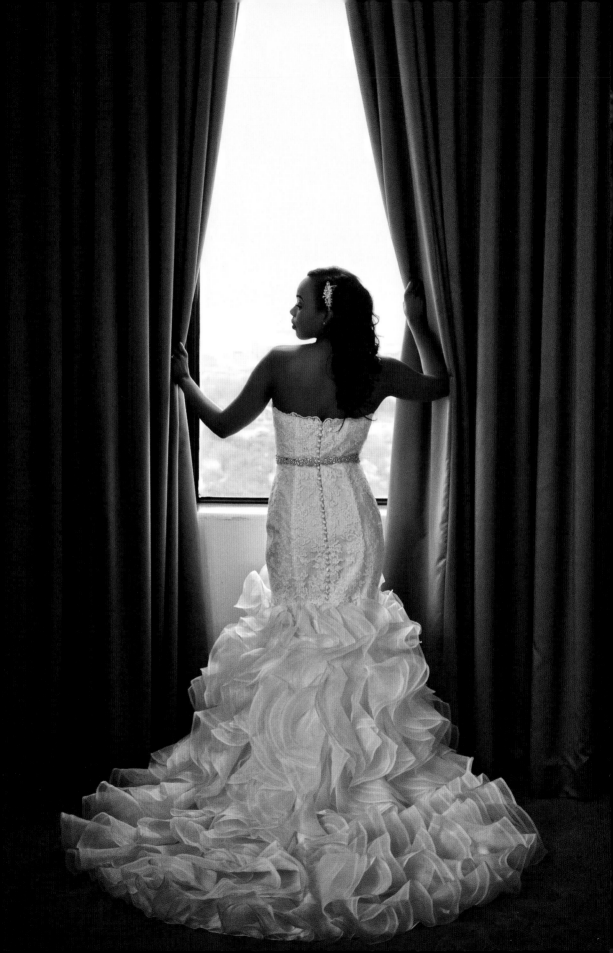

CURTAIN CALL

This room in which the featured image (facing page) was made had beautiful curtains. I had the bride hold open the curtains to allow light in to the room to illuminate her face. I put her in the center of the frame to draw the viewer's attention to her elaborate gown.

I shot from a low angle to ensure that the bride's face would line up with the bright sky area, not the landscape. As a result, there is separation between the bride and the outdoors.

> **Specs**
> Canon EOS 5D MK III • 24–70mm f/2.8 lens • f/4, 1/400 second, ISO 1600

When posing the hands, I like to place one higher than the other to create a dynamic feel in the image.

IN THE ARBORETUM

The bride and groom in the image below were photographed at the Dallas arboretum. They were encircled by trees and foliage, which I burned in to keep attention on the couple.

Note that there is an obvious foreground (the grasses), middle ground (the couple), and background (the trees) in this image. By carefully constructing your image, you can create a sense of visual harmony or balance throughout the frame. Also, by employing three distinctive image areas as we did here, you enhance the perception of dimension and depth in the image.

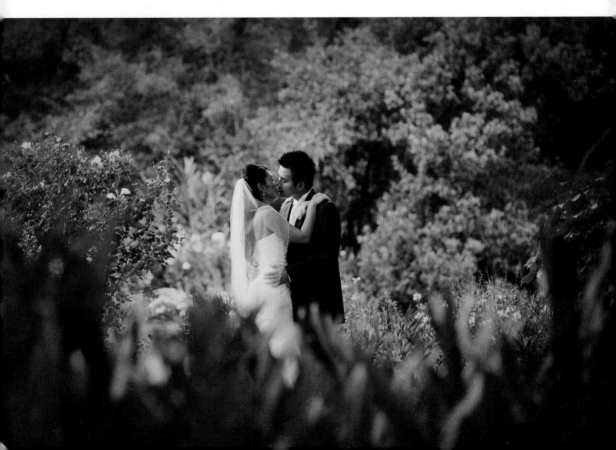

To Grandmother's House We Go

AN EMOTIONALLY CHARGED LOCATION

This bride chose her grandmother's house as the place she and her attendants would prepare for the wedding.

It was a remarkable place; there were pictures everywhere and a wide variety of other special items in the home that were sure to stir emotions for the bride on her wedding

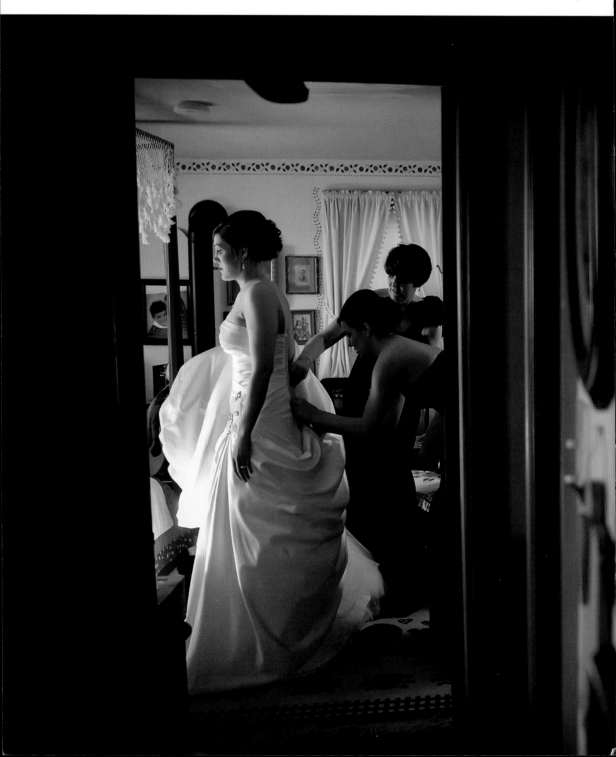

day. It was great to be able to record this special occasion in a place that already held so many cherished memories.

CONCEPTUALIZING THE SHOT

When I noticed the bride's reflection in the mirror on the right-hand wall, I immedi-

Specs

Canon EOS 1DX • 24-70mm f/2.8 lens at 24mm • f/2.8, 1/125 second, ISO 2500

ately knew how I was going to frame this image and document the bride's preparations and her helpers' efforts in getting her dressed.

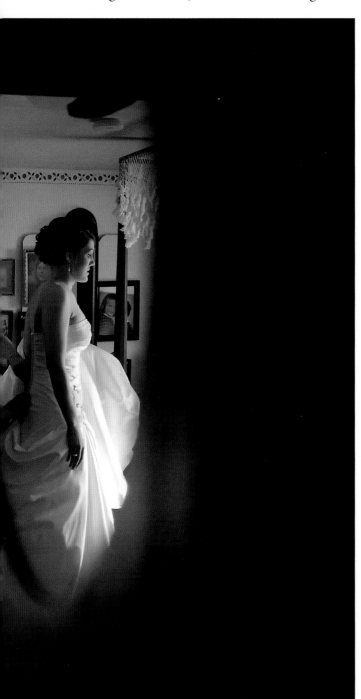

The dark walls on the left and right of the image seem to create a tunnel effect that pulls the gaze right toward the warm, bright tones in the center of the shot. There, the viewer finds the bride and those women closest to her sharing a few moments in preparation for the ceremony.

LIGHTING

The lighting for this image came from a window in front of and to the left of the bride. It was fairly dark in the house, so I used a wide-open aperture, high ISO, and moderate shutter speed to ensure I was able to create a proper exposure.

❝ The dark walls seem to create a tunnel effect. ❞

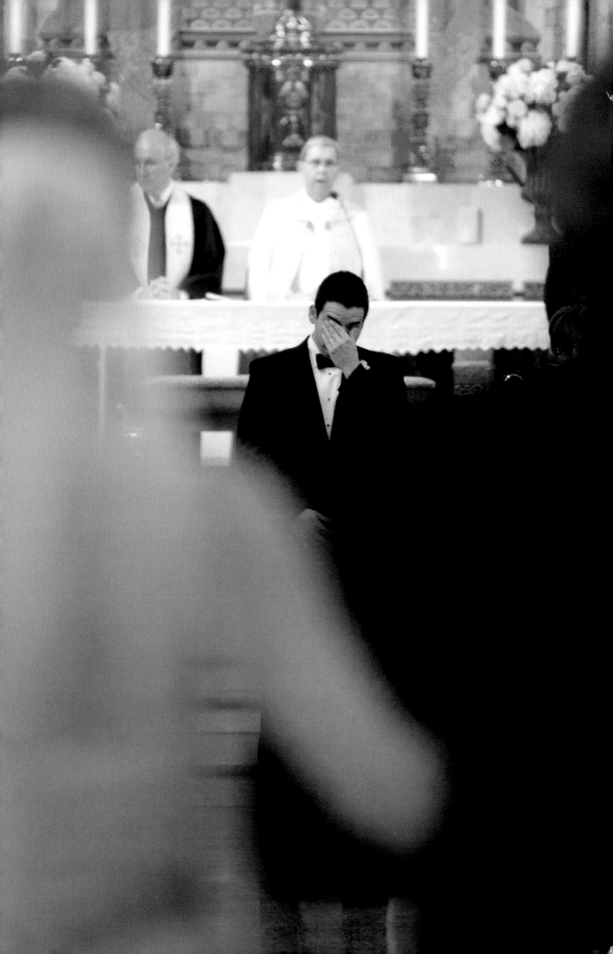

A SIGNATURE SHOT

I try to get a photograph of the groom between the bride and her father as they are walking up the aisle to the altar. It's a great way to frame the groom, who will likely be showing emotion—whether brushing away tears or smiling broadly— as he watches the bride approach. To keep the emphasis on the groom, I focus on him and keep the bride and dad in soft focus. This has become a signature image for me. It helps to tell a beautiful story.

Specs

Canon EOS 1DX • 70–200mm f/2.8 lens at 200mm • f/2.8, 1/125 second, ISO 3200

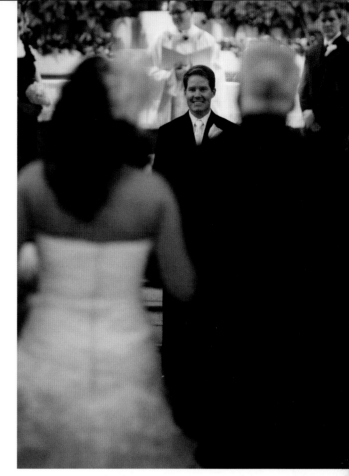

BE READY FOR EMOTIONS

Or course, grooms aren't the only ones whose emotions sometimes overflow during the ceremony.

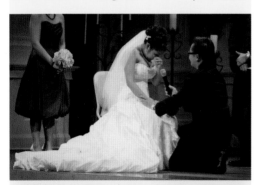

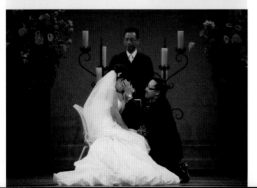

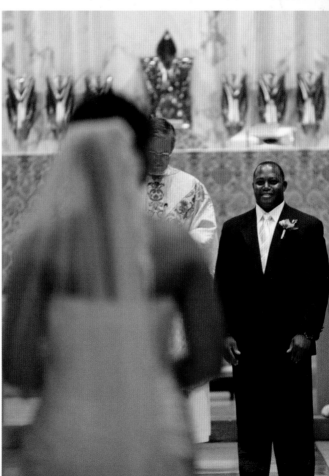

A DRAMATIC ENDING

The image above was made as the bride and groom were running out to exit the reception at the end of the evening. I love this shot. The guests lined the walkway with lit sparklers to see the newlyweds off on their way to begin the next chapter of their lives. It was quite dark. There was very little light coming from the paper lamps, which were, for the purposes of the photo, more decorative than functional. The only other light came from the sparklers.

LIGHTING AND POSING

To capture the shot, I had my assistant positioned at camera right, with an off-camera flash at about the 2:00 position. The groom grabbed the bride, dipped her, and kissed her—it was a wonderfully dramatic gesture that I was ready to capture.

> **Specs**
> Canon EOS 1DX • 16-35mm f/2.8 lens at 16mm • f/4, 1/100 second, ISO 2000

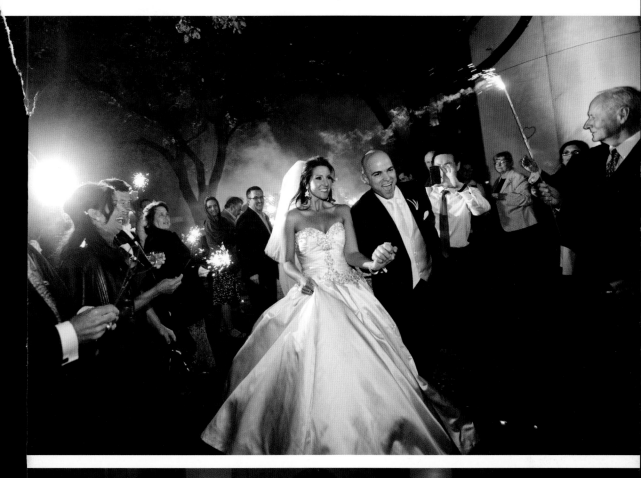
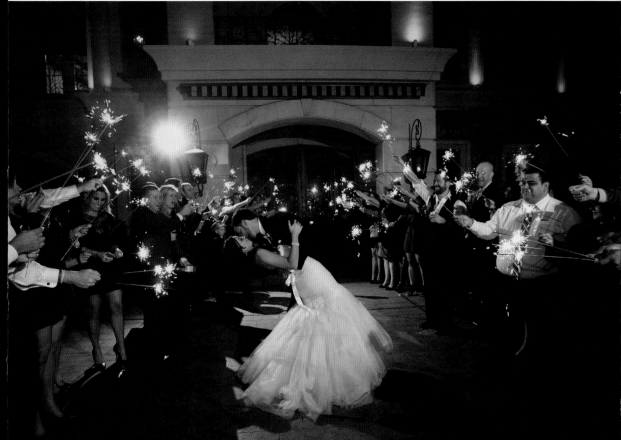

Index